IMAGES
of America

MUSIC IN
WASHINGTON
SEATTLE AND BEYOND

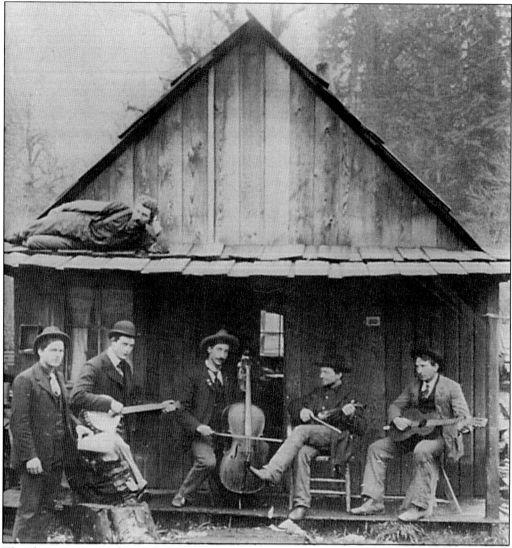

This dapper quartet of anonymous musicians were photographed with a banjo, fiddle, cello, and guitar at a rustic Tacoma cabin by U. P. Hadley in 1893—a year when the port town's population of 50,000 briefly surpassed its nearby rival, Seattle. The foursome appears quite relaxed—perhaps they posed just before the panic of 1893 hit and staggered Tacoma's economy. (Courtesy Historic Tacoma, Inc.)

ON THE COVER: In the fall of 1964, the Seattle Center's Exhibition Hall (305 Harrison Street) was the site of the biggest show thus far for an up-and-coming Northwest band—Paul Revere and the Raiders. Though their huge radio hits, "Just Like Me," "Hungry," "Kicks," etc., were yet to come, the combo's sweaty and maniacally exuberant stage show was already drawing thousands of fans. (Courtesy photographer Gino Rossi.)

IMAGES
of America

MUSIC IN
WASHINGTON
SEATTLE AND BEYOND

Peter Blecha

ARCADIA
PUBLISHING

Published by Arcadia Publishing
Charleston, South Carolina

Printed in the United States of America

Library of Congress Control Number: 2007930840

For all general information, please contact Arcadia Publishing:
Telephone 843-853-2070
Fax 843-853-0044
E-mail sales@arcadiapublishing.com
For customer service and orders:
Toll-Free 1-888-313-2665

Visit us on the Internet at www.arcadiapublishing.com

This book is dedicated to the many Pacific Northwest musicians—both those represented within these pages and all those that are not—who have entertained and inspired me over the years.

CONTENTS

ACKNOWLEDGMENTS

Seattle is a great music town. But the area's many libraries, museums, historical organizations, and institutional archives also make it an absolutely fantastic place to conduct research, and I thank the staffs of the following for their help with this project: the Washington State Regional Archives, Seattle Municipal Archives, Seattle Public Library, Museum of History and Industry (MOHAI), University of Washington's Special Collections Division, Tacoma Public Library, and the Snohomish County Museum.

This book is the culmination of over 25 years of research, an endeavor that has resulted in the documentation of more than 5,000 local musical ensembles—far too many to have included in this brief tome. So instead, I chose from among the most interesting images that were accessible. Please know that unless otherwise noted, all vintage band promotional photographs, event posters, rare records, and other scarce artifacts depicted within are from my own personal collection. Efforts have been made to determine and credit the original photographers and/or current owner of copyrights wherever possible, but as we do not wish to overlook anyone's work, we would still appreciate learning of any further details for inclusion in any future printings.

This book would not have been possible without the help and support of numerous bands and various record labels, including Seafair/Bolo Records, Celestial Records, Jerden Records, Nastymix Records, and Sub Pop Records. Special thanks to Julie Woods, Vandenberg Communications, and Pearl Jam. In addition, I salute New York's Norton Records for working to keep the Northwest oldies flame burning; Tacoma's collector king, Jeff Miller; and several of the Northwest's finest music photographers—Gino Rossi, Jini Dellaccio, Cam Garrett, Lance Mercer, and Charles Peterson—who have all generously supported this project.

Lastly I wish to thank two particular women—my senior graphic designer (and lovely wife), Kate Race, for all her help in optimizing these photographs, and my spirited Arcadia Publishing editor, Julie Albright—both of who share an enthusiasm for this project that one could suspect is fueled at least in part by fond personal memories of their girlhood crushes on the Raiders' dreamy-eyed, ponytailed singer, Mark Lindsay.

Appreciation to all!
Peter Blecha

INTRODUCTION

Bands and bandstands. Dancers and dance halls. Photographic images of a full century worth of these (mostly) long-gone people and places provide us with a visual sense of the evolutionary arc of music-making history in the Pacific Northwest. Such photographs help track the interesting changes in ensemble sizes, instrument preferences, hairdo and stage-apparel trends, and technological advancements that occurred over time. But they also illustrate the deeper saga of how a scant few generations of local music enthusiasts went from holding quaint, provincial hoedowns on the top surfaces of enormous old-growth tree stumps, all the way to establishing a powerful, regionally based, modern music industry.

The story of music created in this particular neck of the woods is one that actually encompasses a several hundred–year time span, and of course, the first homegrown songs were those that fulfilled the cultural needs of the indigenous First People of the region. Then came sequential waves of inbound musical traditions imported here by Spanish and British explorers and sailors and French-Canadian fur trappers. Finally there were the songs brought in by missionaries, soldiers, loggers, cowboys, Oregon Trail emigrants, Gold Rush miners, and a huge influx of World War II–era military personnel and defense industry workers.

In the early times, settlers played music to dispel feelings of loneliness at pioneer homesteads, often located many miles from a neighbor. Then, as settlements grew, people used music to entertain one another, hymns were sung during church services to help create bonds of community, and dances were held to foster an air of jollity in taverns. As pioneer communities matured and the population expanded, demand naturally grew for a more sophisticated arts culture, and with that came a need for ever-greater performance venues. And so arose the Wild West–era, wooden-planked "opera houses," grand Victorian theaters, Prohibition speakeasies and roadhouses, and eventually all of the massive auditoriums, amphitheaters, stadiums, arenas, and coliseums that would be built in conjunction with Washington state's three World's Fairs: Seattle's 1909 Alaska-Yukon-Pacific Exposition, 1962's Century 21 Exposition, and Spokane's Expo in 1974.

But for the longest time, intrepid folks with hopes of establishing an effective music industry in the isolated backwaters of the Northwest would see their dreams go largely unfulfilled. And one major reason is that the region's finest talent was perpetually being siphoned off. Indeed, perhaps the central narrative thread here is the fact that America's true music business capitols—New York City, Hollywood, and later Nashville—have always worked as an irresistible magnet to ambitious musicians from the hinterlands who feel the beckoning lure of fame and fortune and can't resist embarking on the uncharted path to stardom.

Given that the region's first decent local recording facilities—Portland's John Keating Studios and Seattle's Western Recording Studios—wouldn't be established until the 1940s, this situation is quite understandable. But even after the Northwest got its first studios and labels (including Rainier Records, Evergreen Records, Linden Records, and Morrison Records) there would be many notable local musicians who would score major recording deals and/or find fame only after leaving home.

However, at least three times in history a different scenario has played out whereby the sounds created here were so magically compelling that the wider world of music willfully accepted it all on its own terms, and our local songs made an undeniable impact outside of the region.

The first major outbreak was between 1959 and 1960 when the operators of Seattle's first savvy pop label, Dolton Records, managed to bypass various nay-saying, big-time music business insiders and push an impressive string of recordings by area teen bands into the national, and then international, spotlight. And once Dolton had finally kicked open that door, garage bands like the Wailers, Ventures, Kingsmen, and Paul Revere and the Raiders also barged through with their various versions of the region's teen anthem, "Louie Louie," and additional hits. These and other young musicians scattered from Seattle to Portland had taken the basic building blocks of rhythm and blues and rock 'n' roll music and reassembled them into a rather unique form that was initially called the "Sea-Port Beat" (later becoming more widely known as the Original Northwest Sound), and over the following few years the Northwest suddenly—and for the first time ever—became linked in the public's mind with its distinct music.

The second eruption would occur only after some rather long, lean years when few local artists broke out, and the overall scene seemed to lose its collective momentum. What no one could have really known back then was that the task of pushing the Northwest's music back onto the national pop culture radar screen would, once again, ultimately require the skills of a new startup label. A company with fresh ideas and new contact networks—in effect, a repeat of 1959 when Dolton worked their magic. And it was not even a rock 'n' roll label that achieved this, but rather a hip-hop-oriented firm called Nastymix Records that was founded in 1985 by local radio DJ Nasty Nes Rodriguez and an up-and-coming young rapper known as Sir Mix-a-Lot.

With Mix's early rap hits selling like crazy and sparking widespread amazement that such cutting-edge sounds could emanate from Seattle, Nastymix went all out and single-handedly reenergized the foundering local music scene. The label's growing staff settled into a swank corporate headquarters downtown, signed more rappers (Kid Sensation, High Performance, and Criminal Nation) who enjoyed their own hits, and along the way threw the most extravagant and fun gold record celebration parties that the Seattle music business had ever witnessed.

Meanwhile, the third great local musical uprising happened between about 1988 and 2005 when the Northwest's grunge rock bands went from being a strictly local phenomenon—performing in dingy punk rock dives and maybe selling a couple thousand copies of their records—to being symbols of an entirely self-contained musical ecosystem. By the time leading bands like Nirvana and Pearl Jam released groundbreaking albums around 1991, Seattle's grunge scene itself was being celebrated as the most important underground youth-culture movement on planet Earth.

For the next several years, grunge simply dominated pop culture in a manner that hadn't been seen since the English bands of the British invasion (or Haight-Ashbury's hippie bands) had likewise done three decades prior. It seemed that every music magazine featured grunge bands on their covers, radio stations saturated the airwaves with the new Seattle sound, MTV basically morphed into an all-grunge-all-the-time network, fashion runways in New York and Paris (seriously, if a bit ludicrously) aped the low-brow Seattle look, bands from elsewhere tried to mimic the Seattle sound, and many books—and even a few movies (Singles and Hype)—about the scene were produced.

But then, inevitably one supposes, the anti-Seattle backlash began: non-Northwest bands, fatigued by all the over-the-top, industry-generated hype, cut protest songs like "I Left My Flannel (In Seattle)" and "Sick of Seattle." MTV and national radio chains started focusing elsewhere, and the general public sensed that the grunge movement had had its moment in the sun.

Yet, it was only after those exhilarating grunge years had subsided that we were able to clearly see exactly what had all just happened and to understand what the real legacy of that period would be. Still, even after those heady days of grunge glory, we should not forget that the Northwest music scene had really been a longtime in the making and that it was built upon trails blazed by earlier musicians—some of whom today are sadly next to forgotten. Just consider some of the local African American "rude jazz" and rhythm and blues groups whose names alone evoke good

times gone by, like Tacoma's Swinging Esquires and Seattle's Savoy Boys and Billy Tolles and the Vibrators. Then too there were the early local a cappella doo-wop groups, like Tacoma's Barons and Cool Breezers, Everett's Shades, and Seattle's Five Checks, Fabulous Winds, and Gallahads.

When this book looks back on 1960s rock 'n' roll by focusing on the main bands who helped define the aforementioned Original Northwest Sound, it must also be understood that this is only one layer of the whole story. In fact, as that decade unfolded and various stylistic waves crested, each had some impact on music in the Northwest; during the surfer (and related hot rod) rock era, we had the Beachcombers, Corvelles, Furys, and Gear Grinders; and the British invasion produced Northwest bands like the Ascots, Blokes, London Taxi, Mersey Six, Newcastles, and Prince Charles and the Crusaders.

Soon the 1960s psychedelic era would bring a kaleidoscopic array of paisley-bloused and love bead–bedecked hippie bands, including the American Dream, Magic Fern, Peece, Suspended Purple, Third Stone, Time Machine, Universal Joint, and West Coast Natural Gas. As the 1960s flowed into the 1970s, countless new local bands formed, including Adam Wind, Axis Drive, Cosmic Funk, Equality, Fragile Lime, and the Peace Bread and Land Band. As musical tastes continued to splinter, local fans were soon enjoying various country rock bands like the Uptown Country Boys, Skyboys, and Lance Romance; tavern favorites like Annie Rose and the Thrillers, Dynamic Logs, and Kidd Afrika; hard rockers like Mojo Hand, P.O.W., Chinook, Kiss Porky, and Heart; blues groups like the Brian Butler Band, Isaac Scott Band, and Tacoma's Steakface (with future superstar guitarist Robert Cray); and funk and/or disco combos like Acapulco Gold, Black on White Affair, Epicentre, and Cold, Bold, and Together (with future superstar light jazz reed-man Kenny G.).

While a lot of fun was had during this period, it must be noted that the local music business had somehow managed to once again become ineffectual at launching any notable careers (i.e. neither Heart, nor Robert Cray, nor Kenny G. found fame until after leaving Washington). Worse yet, the outside music biz seemed to have regressed all the way back to square one by studiously ignoring the talents hailing from this area. Indeed, of the exceedingly few Northwest artists who actually managed to score deals with big-time labels in the 1970s—Fragile Lime (Warner Brothers), Gabriel (ABC), Big Horn (CBS), TKO (Infinity), Striker (Arista), Danny O'Keefe (Atlantic), Bachman-Turner Overdrive (Mercury), and Heart (CBS)—only the last three managed to score actual hits.

Finally, as the decade waned, along came the brash, do-it-yourself energy of punk bands like the Accident, Accused, Cheaters, Chinas Comidas, Fartz, Pudz, Refuzers, Solger, Telepaths, and X-15—and post-punk and new wave bands like the Fastbacks, Frazz, Red Dress, Squirrels, Student Nurse, 3 Swimmers, and the Young Fresh Fellows, who almost universally shared a lack of desire to align with giant, corporate record companies and instead often formed their own indie labels to self-distribute their records.

Meanwhile, the local rap scene thrived from the 1980s into the 1990s and grew to include legions of pioneering talents including the Central District Posse, Emerald Street Boys, Ghetto Chilldren, Incredicrew, N. W. Posse, and the Sharpshooters. Then in more recent years, dedicated hip-hop labels like 2MassLine and Noc On Wood Records rose up, as did highly promising acts like Blak, Blue Scholars, Circle of Fire, Common Market, Dyme Def, Fatal Lucciauno, Grayskul, Mr. Supreme, Source of Labor, Unexpected Arrival, the Saturday Knights, and many others.

Reflecting back now on all of this history as a whole, it seems that time and time again the Seattle scene has proven its worth, and in hindsight, it can be clearly seen that even in normal times, when the media spotlight is not glaring on the Northwest scene, our musicians have always worked hard to entertain us. But having experienced the boom-or-bust cycle a few times by now, Seattle can also conclude that the natural ebb and flow of America's pop culture ensures that the localized intensity of, for example the grunge era, could never be sustained indefinitely.

This is perfectly okay, because even during relatively quieter times, like the recent post-grunge years, a remarkable number of impressive talents will emerge here as have rockers like the Presidents of the United States of America, Sleater-Kinney, Modest Mouse, Murder City Devils, Vendetta

Red, the Makers, Harvey Danger, Death Cab for Cutie, Visqueen, Smoosh, Aqueduct, Speaker Speaker, Patient Patient, Amber Pacific, Cave Singers, Zero Down, Surface Tension, the Blakes, the Lashes, Aiden, and the Shins.

Oh, and did I mention Seattle's latest young jazz diva, Sara Gazarek, whose CDs and concerts have recently been garnering critical praise nationally? Or how about all of the new country voices from this area? Singers and songwriters like Seattle's Jesse Sykes and Christy McWilson, Tacoma's Neko Case and Vicci Martinez, Buckley's Blaine Larsen, Steilacoom's Lila McCann, and Ravensdale's Brandy Carlisle, each of who has been making waves.

Finally it was interesting to witness the three judges for the popular, televised talent show, *American Idol* making a big point out of dissing Seattle after tryout competitors here didn't meet their approval. Complaining that Seattle had produced the least talented singers they'd ever heard, Randy Jackson surmised, "There must be something in the rainwater. It makes them wild, insane, maybe depressed. I blame it on the rain." The singers were, claimed Paula Abdul, "unusually fantastically delusional," and "absolutely atrocious" according to Simon Cowell. Yet in the end, the public voted in 2007 to make two Washington state singers *American Idol* finalists: Federal Way's controversial preteen heartthrob Sanjaya Malakar and Bothell's happening human beat box Blake Lewis.

But if it is true that Seattle's infamous rainfall can justly be blamed for producing all the wildly talented musicians who have sprouted up here, it would seem our drizzly future can only promise that new musicians will continue to create cool sounds here in the Northwest. In fact, I think I hear the distant rumble of a fresh storm front rolling in.

One

EARLY TIMES

The fledgling community of Seattle got its first public room—and with that the site of the first amateur entertainments—when the Yesler Mill Cookhouse was built in the winter of 1852–1853. The Bell Sisters, daughters of a founding family, were among the first local talents to perform for their tiny community. This time period also saw the first stirrings of what would become the village's first organized musical ensemble, arranged by a sawmill worker named George Frye, a member of the Bethel party that had crossed the Oregon Trail in 1853, who successfully recruited a dozen young men and formed the all-volunteer Seattle Brass Band around 1860.

As Seattle grew up and its population increased, the demand for more diverse entertainment opportunities than say simply holding a dance on a tree stump eventually resulted in the construction of a series of downtown venues, including Plummer's Hall, Yesler's Pavilion, and the Grand Opera House, and by the 1890s, a string of bandstands and dance pavilions set in lakeside parks were created, including those in the Madison, Leschi, Richmond Beach, and Juanita Beach neighborhoods.

In the 1890s—but just after the Yukon gold rush had jump-started the Seattle economy and earned the town a well-deserved reputation for hosting a Wild West atmosphere of anything-goes nightlife of boozing, gambling, and dancing—Seattle became the home base for two of America's largest early entertainment empires, the Orpheum and Pantages vaudeville theater chains. Alexander Pantages returned from the gold fields with his profits and in 1904 founded his namesake, a nationwide, 70-unit theater chain, while John Considine's Orpheum chain was anchored with an ornate theater built here a few years later.

Meanwhile, in 1907, Luna Park, called "the Coney Island of the West," opened on the shores of West Seattle, and in addition to carousel rides and other amusements, its bandstand and Dance Palace provided musical entertainments to visitors. Two years later, Seattle held its first World's Fair, the Alaska-Yukon-Pacific Exposition (AYPE), which entertained tens of thousands of attendees with daily musical offerings throughout much of 1909.

The brand-new hamlet of Seattle got its first public room in early 1853 when the construction of a log cookhouse at today's First Avenue and Yesler Way for Henry Yesler's sawmill was completed. The 25-foot-long building (seen *c.* 1866) went on to serve for years as Seattle's town hall, restaurant, church, military headquarters, and a gathering place for musical entertainments.

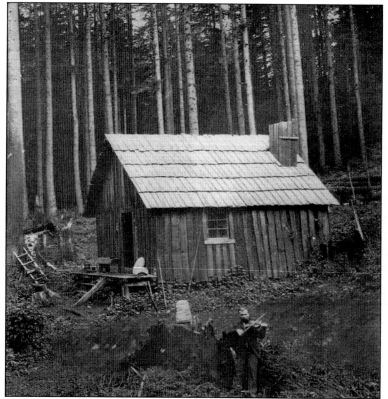

Some Northwest pioneers dealt with the loneliness of life in a backwoods cabin by playing music. This unidentified fiddler and his homestead were photographed somewhere in the northern Cascade Mountains around 1897. (Courtesy U.S. Geological Survey.)

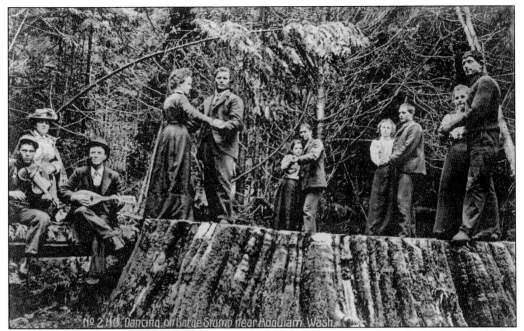

A fiddler and mandolin player provide music for some dancers posing on the surface of a giant, sawed-off cedar tree stump. Various editions of this postcard place the stump dance location as being either near the sawmill towns of Bellingham or Hoquiam.

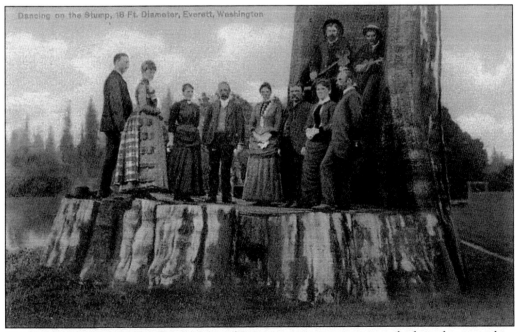

This undated postcard shows an 18-foot-diameter stump serving as a platform for gussied-up dancers and musicians near the timber and port town of Everett.

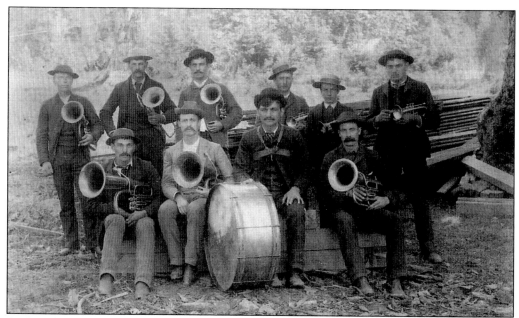

Back in the 1880s, the most fortunate Northwest lumber camps contained a dedicated, if amateur, band that entertained lumberjacks, camp followers, and any visitors that might pass through. (Courtesy Bob Jeniker.)

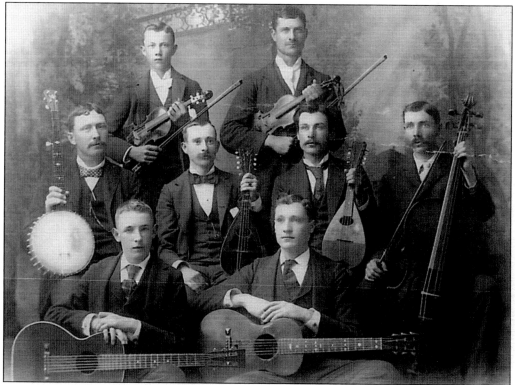

The late 1800s saw the formation of many string bands across the country, including the Snohomish String Band, which was based in that raucous riverside lumber-mill town. (Courtesy Bob Jeniker.)

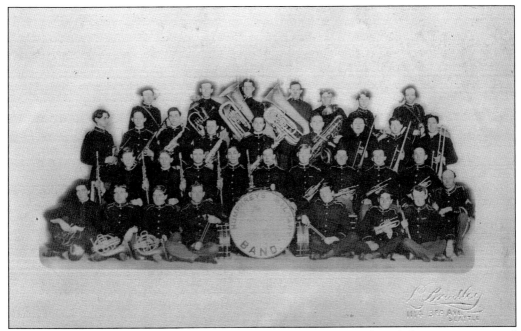

Brass bands were common in frontier towns from the 1860s onward, and this vintage postcard features an early Seattle-based ensemble known as Humphrey's Military Band. (Photography by L. Bradley.)

The U. S. Army's Sixth Infantry band is seen practicing in the woods outside of Spokane around 1908. (Photography by Cutter.)

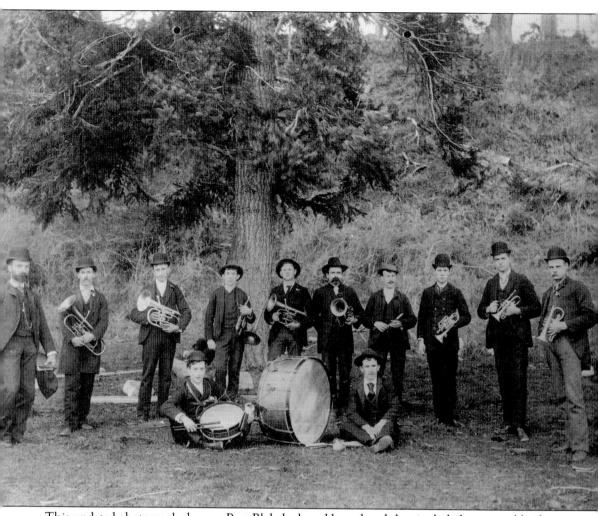

This undated photograph shows a Port Blakely–based brass band that included presumed leader Jimmie Hall (left) of that Bainbridge Island town's prominent Hall Brothers Shipyard family. (Courtesy MOHAI SHS 17296.)

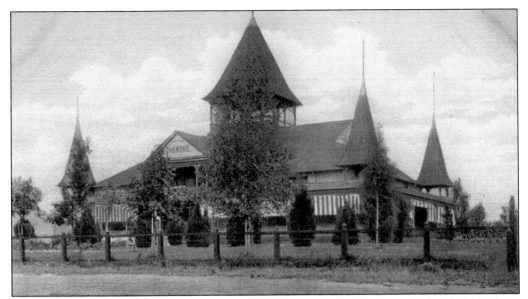

Seattle judge John J. McGilva opened his lakeside Madison Park Pavilion on July 26, 1890. Twice a week, two daily vaudeville shows were followed by an after-show dance, and on Sundays, nearby park benches filled with folks listening to the city's premiere musical outfit, Theodore H. "Dad" Wagner's Band (see page 22), performing outdoors under a wooden band shell.

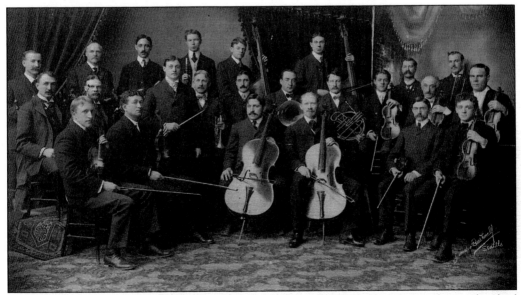

By 1903, the town of Seattle, now a half-century old, could finally boast a population that had reached the size capable of sustaining an actual symphony orchestra, which was originally led by Maestro Harry F. West. (Courtesy MOHAI SHS 5228.)

In 1900, Nellie Cornish moved from Spokane to Seattle to teach piano in a small studio (1108 Broadway Avenue), and by 1914, the esteemed educator had formally founded her Cornish School.

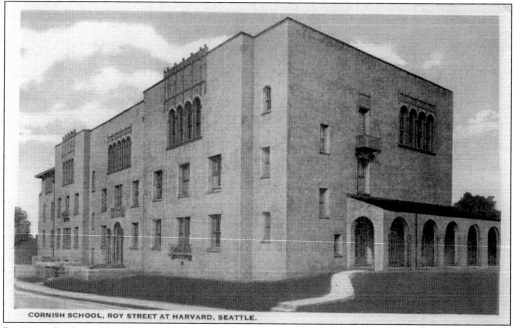

CORNISH SCHOOL, ROY STREET AT HARVARD, SEATTLE.

By 1921, the Cornish School of Fine Arts was based in a new building (710 East Roy Street) and generations of artists—including painter Mark Tobey, dancers Martha Graham and Syvilla Fort, and radical and avant-garde musician John Cage—have studied and/or taught there.

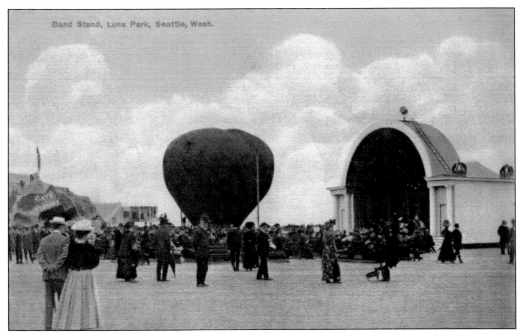

In 1907, Luna Park, the Coney Island of the West, opened in West Seattle and provided various amusements until the *Seattle Post-Intelligencer* warned in 1911 that at "Sunday night dances at Luna Park . . . girls hardly 14 years old, mere children in appearance, mingled with the older, more dissipated patrons and sat in the dark corners drinking beer, smoking cigarettes and singing," and a scandalized city had the place shut down.

In 1908, H. M. Draper and his wife opened the Children's Industrial Home (South 220th and Sixth Avenue) in Des Moines and proceeded to house and educate many homeless and orphaned kids who joined their vaudeville band, the Jolly Entertainers, which toured widely until about 1927.

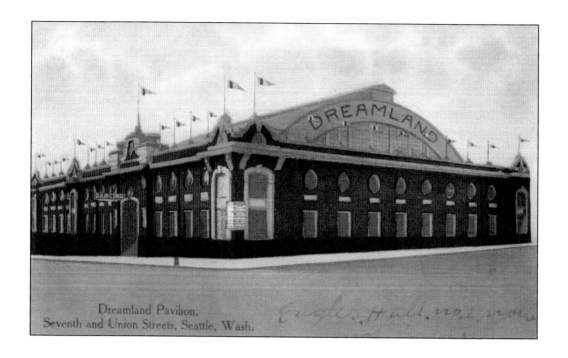

Dreamland Pavilion,
Seventh and Union Streets, Seattle, Wash.

Seattle's Dreamland Pavilion (700 Union Street) was built in 1908, and it immediately drew amazing crowds of over 3,000 young folks to weekly dances. At that time, the collegiate set's wild dance steps—like the Grizzley Bear and the Fox Trot—were being condemned as sinful "animal dances," and as one historian noted, "any couple detected dancing cheek-to-cheek, would be immediately ordered off the floor" by the hall's ever-watchful dance matrons.

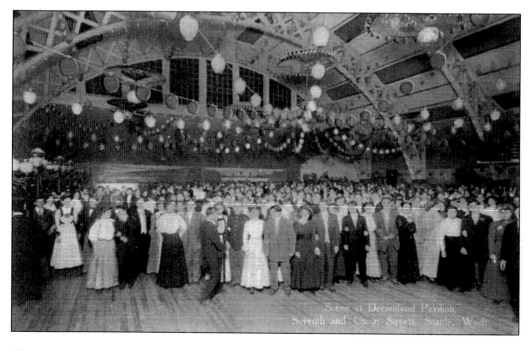

Scene at Dreamland Pavilion,
Seventh and Union Streets, Seattle, Wash.

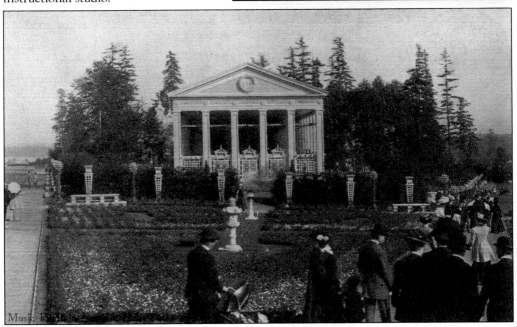

Band Stand, Alaska-Yukon-Pacific Exposition, Seattle, Washington

Photo. Copyright 1909 by Romans Photo. Co.

A gathering crowd is seen milling toward the Music Pavilion on the 12-acre grounds of Seattle's 1909 Alaska-Yukon-Pacific Exposition (AYPE). Plenty of music was provided daily to AYPE visitors, with some of it performed outdoors from a beautiful bandstand. The sheer number of top Hawaiian musicians that performed at the fair has been linked to helping spark the Hawaiian music craze that subsequently swept the nation. Among those players was the self-proclaimed discoverer of the Hawaiian steel guitar technique, Joseph Kekuku, who ended up settling in Seattle and opening an instructional studio.

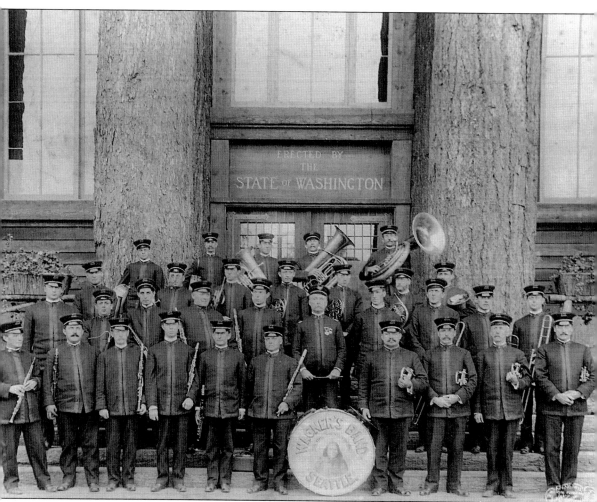

Seattle's first professional ensemble was Theodore H. "Dad" Wagner's Band. Formed in the 1880s, this band lifted the community's spirits after the Great Fire of July 6, 1889, and even performed at the Alaska-Yukon-Pacific Exposition in 1909 (as seen in front of the Washington State Forestry Building). (Courtesy MOHAI SHS 12,079.)

Two

MAINSTREAM MELODIES

The early 20th century offered Seattle's mainstream music fans plenty. The Seattle Symphony Orchestra launched its debut season in 1903, many music instructors held student recitals, and various church-related ensembles and community chorale groups gave public performances. In time, there would also be concerts by famous touring stars at the Orpheum, Pantages, Moore, Metropolitan, and Paramount Theaters.

But Seattle was still far from being world class, as some longed for it to be. The first major homegrown talent who left for greener pastures was Olympia's Theo Karle. After gaining a local reputation as a fine church singer, Karle headed off to New York City, where he was discovered around 1916 by Victor Records, who billed him as "America's Great Tenor." He became a star who cut over 100 songs and enjoyed a long international career.

In 1922, Seattle got its first commercial radio station, KJR, but it would be still another two decades before the town had its own recording studio. So the very first, locally recorded, 78-rpm discs came about in the late-1920s when roaming field agents for major record companies that swung the Northwest using portable gear recorded the area's best ballroom dance bands, including Seattle's Vic Meyers's and Jackie Souder's bands and Spokane's Garden Dancing Palace Orchestra. The 1930s brought a string of roadhouse dance halls—Seattle's Parker's Pavilion, Midway's Spanish Castle, Bremerton's Perl's Ballroom, Tacoma's Crescent Ballroom, and Olympia's Evergreen Ballroom—that would host many a fabled dance.

As the years passed, the Northwest saw many new radio stations go on-air with a number of local talents (including folkie guitar strummer Ivar Haglund), and in 1948, Seattle's first television station, KRSC (later KING-TV), began broadcasting, and the options for musical entertainment increased yet again. The 1950s brought additional television stations to the area and a sort of golden era of local entertainment began with various shows, including country programs like KTNT's *Bar-K Jamboree*, KMO's *Bill and Grover Show*, and KOMO's *Evergreen Jubilee*, airing weekly. Then there were the early kiddie shows, like *Sheriff Tex's Safety Junction* and Stan Boreson's *KING Klubhouse*, which often featured music and mirth for mainstream, middle-class families.

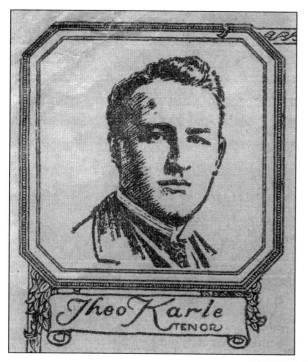

Theo Karle
TENOR

Olympia's Theo Karle first gained renown locally as a church singer, but after heading to New York City, he scored a recording deal with the big-time label Victor Records in 1916 and was soon heralded as "America's Great Tenor," an international star who recorded an estimated 100 songs.

Paul Goerner

Instructor: Banjo, Mandolin, Guitar, Ukulele and Hawaiian Guitar, Tenor Banjo.

HEADQUARTERS FOR

Steel Guitar and Ukulele Music

302 Yale Building, Phone ELiot 8191

Paul Goerner's American-Hawaiian Quartet performed locally around 1915, and he also offered instruction in "Banjo, Tenor banjo, Mandolin, Guitar, Steel Guitar, Ukulele and Hawaiian Guitar" from his downtown Seattle studio (302 Yale Building).

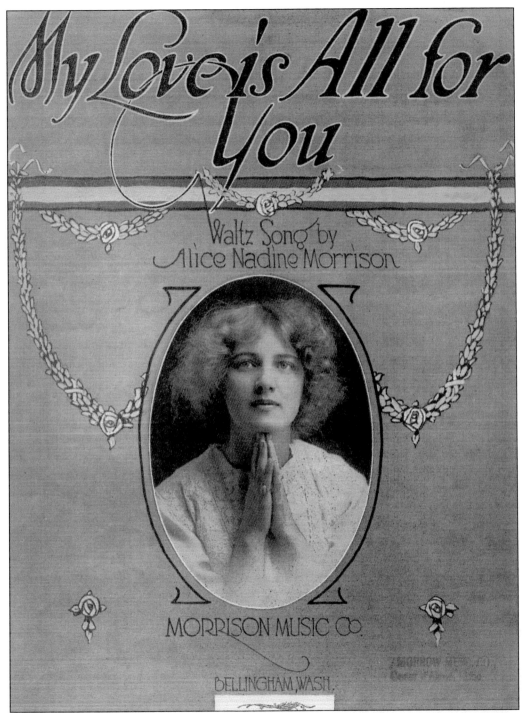

In 1920, Anacortas's silent movie theater organist, Alice Nadine Morrison, scored national hits with "My Love Is All for You" and "Love's Ship." The resultant fortune would support her and her husband's string of dance schools, dance halls, and one of Seattle's first recording studios and labels, Morrison Records.

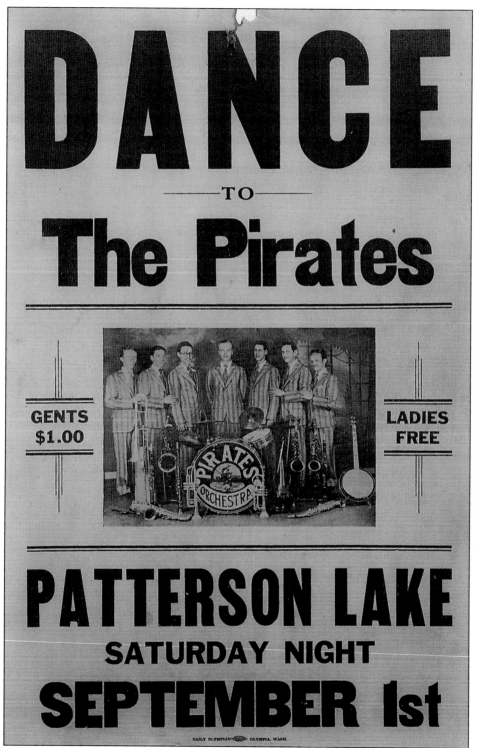

This 1923 poster, printed in a small shop in Olympia, promotes a public dance held at Shelton's Patterson Lake hall featuring a South Puget Sound–area band, the Pirates.

The Butler Hotel was constructed (at Second Avenue and James Street) in the immediate aftermath of the great Seattle fire on June 6, 1889, and was the scrappy town's first grand hotel. For decades after, it was the town's swankiest beverage emporium and dance spot.

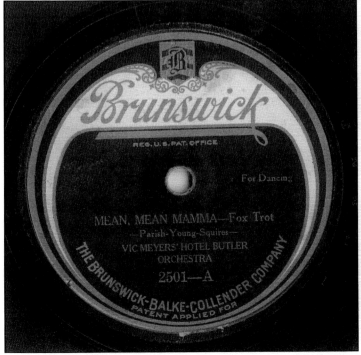

In August 1923, roaming field agents for New York City's Brunswick Records arrived in Seattle and cut Vic Meyers's band at the Butler. That event resulted in the release of this 78-rpm disc, including "Mean Mean Mama" and "Shake It and Break It," making it the first notable recording ever cut in Seattle.

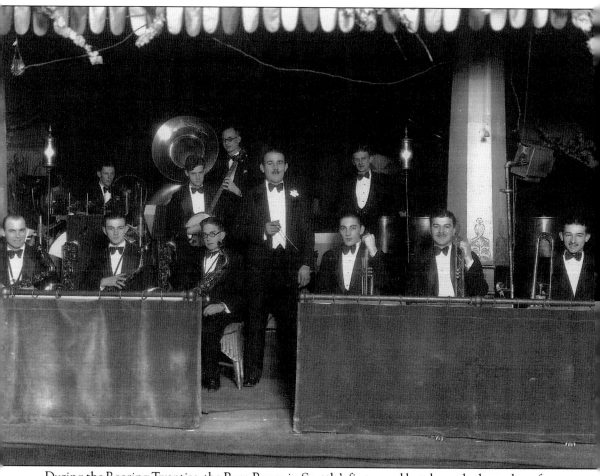

During the Roaring Twenties, the Rose Room in Seattle's first grand hotel was the home base for Victor Meyers and his Hotel Butler Orchestra, and it was also the site of the town's first important recording session. Meyers remained a prime *bon vivant* for years, and when Prohibition was finally repealed in 1933, Seattle celebrated at his Club Victor (2221 Fourth Avenue). (Courtesy PEMCO Webster and Stevens Collection, MOHAI, 83.10.3858.8.)

Two of the Seattle area's most popular Roaring Twenties dance bands were "Toots" Bates and his Highway Pavilion Orchestra and Eddie Harkness and his Olympic Hotel Orchestra; both are shown here in 1925. (Above, photography by Hartsook Studio.)

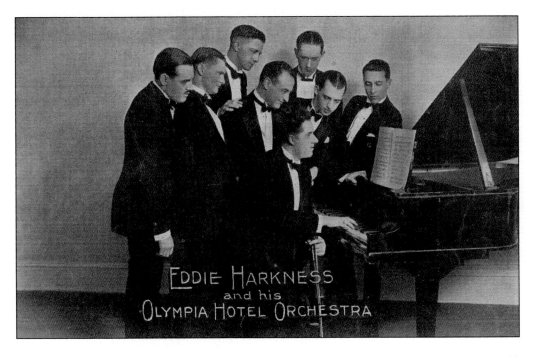

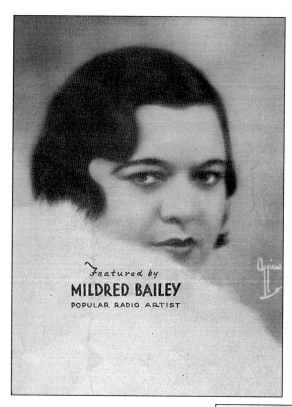

Featured by
MILDRED BAILEY
POPULAR RADIO ARTIST

Mildred Rinker first worked as a teenage clerk in Spokane's Bailey's Music shop (818 West Sprague Avenue), then sang nights at Charlie Dale's speakeasy, and finally resurfaced in Hollywood as Mildred Bailey the singing star. Historians regard her debut hit, "Rocking Chair," as the very first recording by a "girl singer" with a big band.

Back in Spokane, Rinker's younger brother Al and his crooning college pal Bing Crosby were determined to follow her footsteps to fame. On October 15, 1925, they left for California but made a stopover first to hear Jackie Souder's band at Seattle's Butler Hotel. Within a year, the Rhythm Boys were recording for the big-time label, Columbia Records, and Crosby would ultimately be recognized as the "most popular and influential media star of the first half of the 20th century," and the "World's Most Recognized Voice."

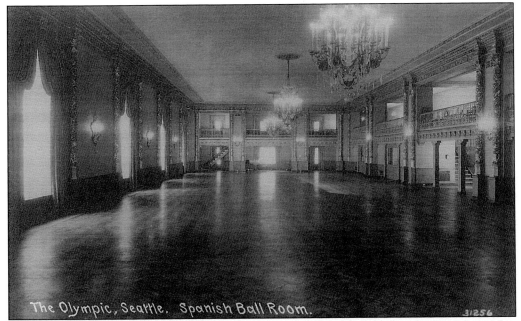

In 1930, Paul Whiteman and his orchestra (which included the Rhythm Boys) performed at Seattle's Olympic Hotel (Fourth Avenue and University Street), whose fine Spanish Ballroom would host many a concert and dance in the decades hence.

In 1930, Dick Parker opened a ballroom in North Seattle (17001 Aurora Avenue) and began holding decade's worth of dances initially featuring Seattle's Putt Anderson and his Dixieland Band and then orchestras led by Frankie Roth, Burke Garrett, Max Pillar, and Jackie Souder. (Courtesy Seattle Municipal Archives.)

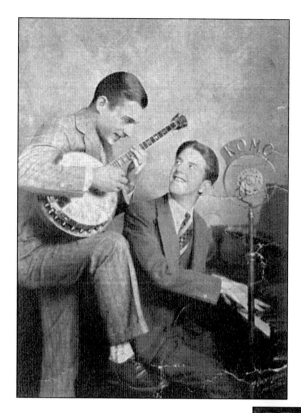

In the early days of commercial radio, stations like Seattle's KJR, KOL, and KOMO each employed a staff of on-air talents that included announcers, singers, and musicians. Jimmy and Bob—a musical duo who were billed as "the Joy Boys"—performed as regulars on Seattle's KOMO radio around 1928.

Elmore Vincent was a singer/yodeler who performed weekly, as "the Northwest Shanty Boy," on Seattle's first commercial radio station, KJR, and specialized in provincial folk tunes like "Song of the Lumberjack," which was included in this 1932 song folio.

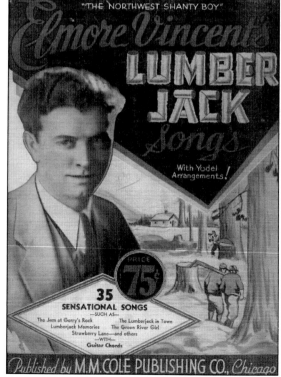

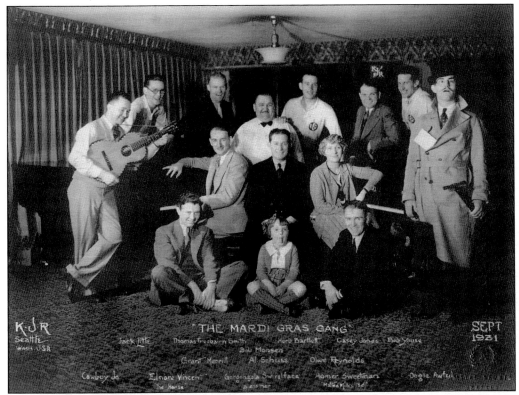

This 1931 image shows the Mardi Gras Gang—a Seattle crew that included two pianists, Cowboy Joe, and noted singer/songwriter Elmore Vincent—who entertained listeners from the broadcast studios of KJR (1326 Fifth Avenue). (Photography by Amstel Studio.)

This 1934 image shows the KOL Carnival Gang, which featured four guitarists and various other on-air entertainers who broadcast live daily from their basement studios at Seattle's Northern Life Towers (1212 Third Avenue).

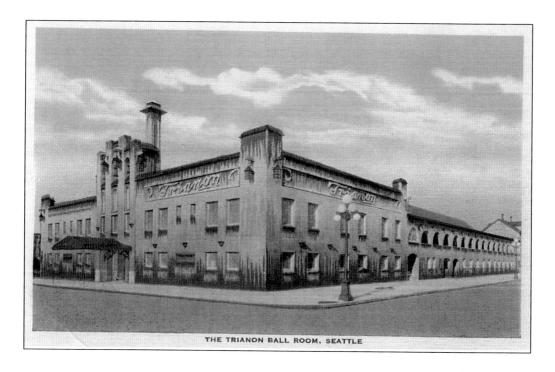

THE TRIANON BALL ROOM, SEATTLE

John Savage, the former manager of the Butler Hotel's Rose Room, opened the Trianon Ballroom at Third Avenue and Wall Street in 1927. Hyped as "the largest dance hall west of Chicago," this beautiful venue served for three decades as a popular dance spot that featured all the top national and local bands.

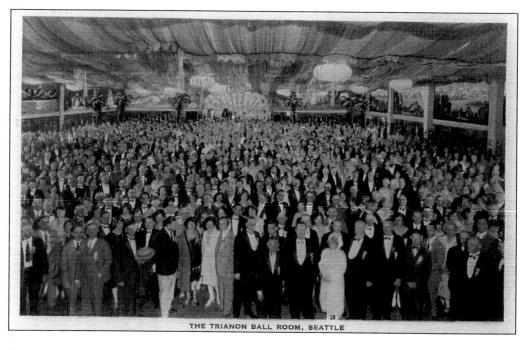

THE TRIANON BALL ROOM, SEATTLE

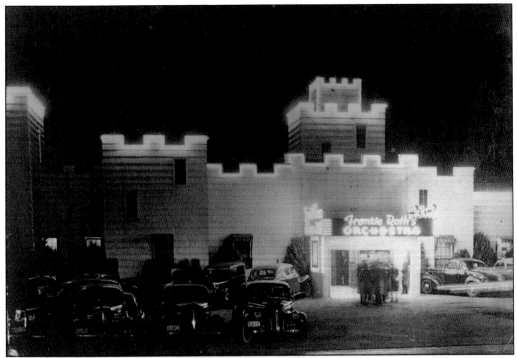

Built in 1931 by Archie Bacon and Frank Enos, the fabled Spanish Castle Ballroom, located on the northwest corner of old Highway 99 and the Kent-Des Moines Road, booked Seattle's Frankie Roth Orchestra for its grand opening and over the decades featured many touring stars. (Courtesy Zenith Historical Society.)

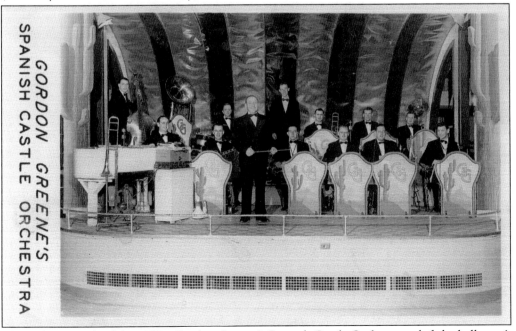

Throughout much of the 1950s, Gordon Greene's Spanish Castle Orchestra ruled the ballroom's dance scene until the baby boomer's rock 'n' roll revolution ousted them in 1959.

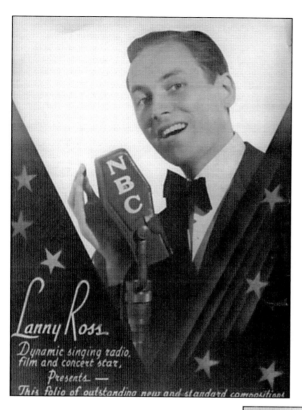

In 1936, Seattle's Lancelot "Lanny" Ross was voted by music fans as Most Popular Male Vocalist in America (surpassing even the King of the Crooners Bing Crosby), and by 1948, he was hosting NBC's televised national program *The Lanny Ross Show.*

In 1939, Seattle businessman Michael Lyons opened his popular Show Box Cabaret at First Avenue and Pike Street. This 1952 advertisement touts nightly dances led by Norm Hoagy and his Orchestra, who cut local records, including the up-tempo gem "Showbox Boogie."

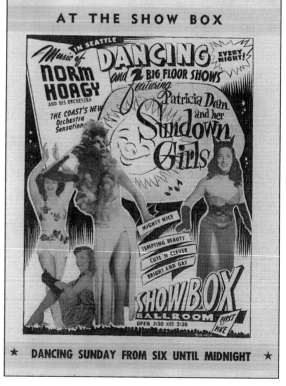

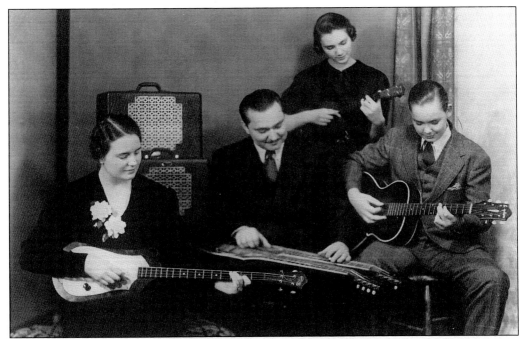

Seattle's Paul H. Tutmarc established himself as a successful radio and concert singer, music shop owner, instructor, and pioneering electric guitar maker. His family band included his children, Jeanne and Bud, and first wife Lorraine, who played the revolutionary electric bass guitar he invented in 1936. (Courtesy Paul "Bud" Tutmarc.)

In 1944, KVI radio DJ Buck Ritchey formed a country band, the K-Six Wranglers, that included steel guitarist Paul Tutmarc and his new singer/guitarist wife, Bonnie (also known as "Bonnie Guitar"), and Jack Guthrie, who debuted his soon-to-be-famous tune "Oklahoma Hills" at a Tacoma gig. They are seen here at the Old Mill roadhouse in Puyallup.

By 1948, Jesse Lee "Arkie" Shibley and his Mountain Dew Boys were hosting their own weekly hillbilly radio show on Bremerton's KBRO and performing at various local halls. Shibley formed Mountain Dew Records and self-issued his classic "Hot Rod Race," which caught the attention of the established California-based label Gilt-Edge, who had the band rerecord it in 1950. The tune became a national hit.

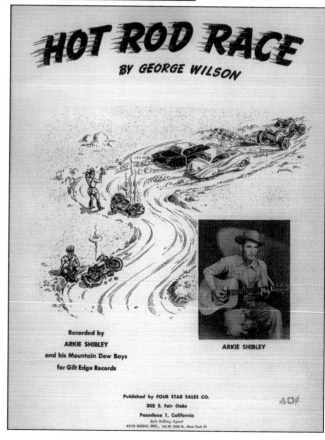

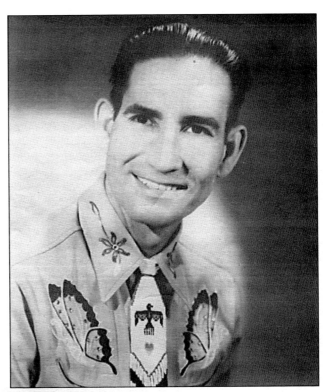

Spokane's Bell Tavern hired Charlie Ryan's Montana Range Riders in 1935. In 1948, Ryan formed the Timberlines. In 1957, they cut the "Hot Rod Race"–inspired "Hot Rod Lincoln" at KPEG radio's studio and self-issued it on Souvenir Records. Quickly picked up by California's 4-Star Records, Ryan's "Hot Rod Lincoln" 45 became a classic that remains a milestone in the continuum that ties country music to that early form of white rock 'n' roll called "rockabilly."

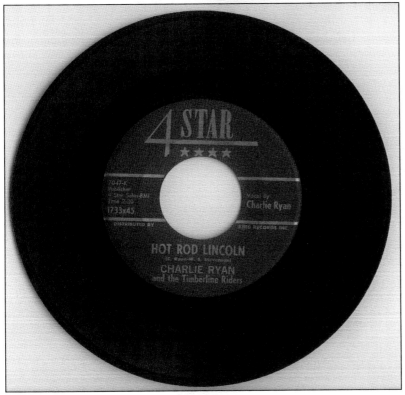

In 1946, Seattle's irrepressible Ivar Haglund opened his famed waterfront restaurant, Ivar's Acres of Clams, but he was already well known as a folksinger who had befriended visiting troubadours Woody Guthrie and Pete Seeger and hosted his own radio shows on KRSC and KJR. (Courtesy Ivar's Restaurants.)

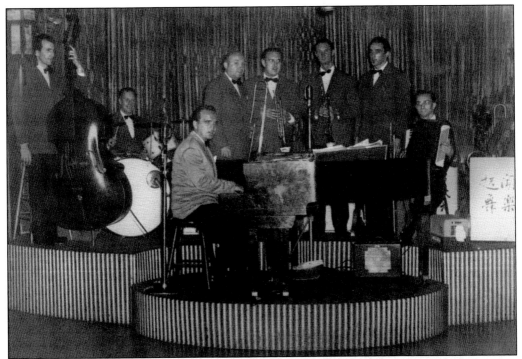

Bob Harvey led a popular band that recorded for Seattle's pioneering record company, Linden Records, in the late 1940s and early 1950s. They are seen here at Seattle's China Pheasant restaurant, 10315 East Marginal Way, around 1948.

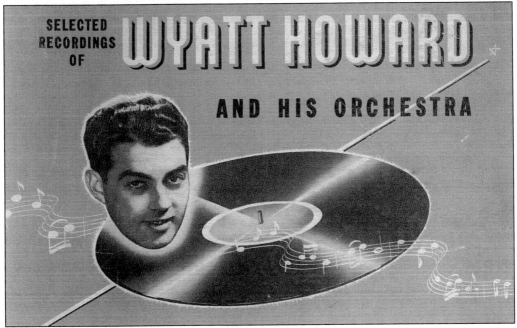

Wyatt Howard and his Orchestra drew polite dance crowds out to the Seattle Town and Country nite spot, 12319 Roosevelt Way NE, and also recorded a few discs for the local Linden Records company in the late 1940s and early 1950s.

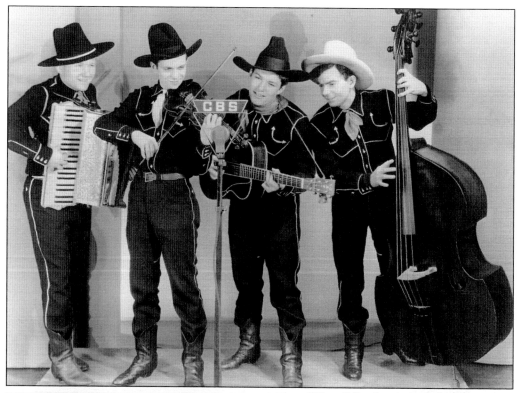

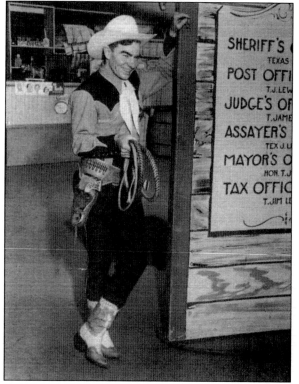

"Texas" Jim Lewis (right) was a singing cowboy star of several 1930s Hollywood movies. His band, the Lone Star Cowboys, first toured the Northwest in 1940. In 1950, Jim Lewis and his band settled in Seattle where he began years of hosting the area's first televised kiddie show, KING-TV's *Sheriff Tex's Safety Junction*.

Tacoma banjoist Harry Skarbo got his showbiz start working at Seattle's KVI radio studios (in the Camlin Hotel, 1619 Ninth Avenue) in 1927. By 1948, he'd gained national fame as Yogi Yorgesson and was touted as "America's King of Scandinavian Humor."

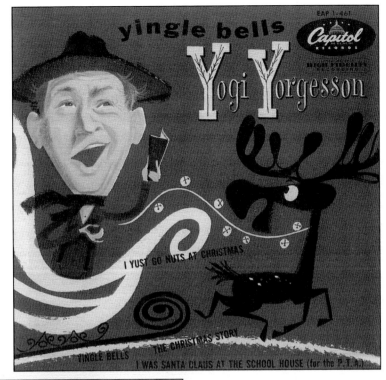

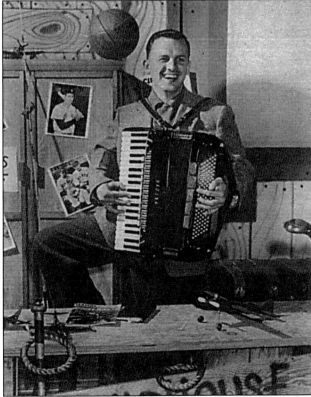

Inspired by Yorgesson, University of Washington student and accordionist Stan Boreson developed his own style of "Scandihoovian" dialectical humor. In 1949, he began recording for Seattle's Linden Records, and 1955 saw the debut of his own long-running kiddie television show *KING's Klubhouse*.

In 1949, lounge pianist Billy Tipton and his trio began playing various Northwest nightclubs. Only upon passing away in 1989 did the world, including the wife and kids, learn that he was actually a she who had been born as Dorothy Lucille Tipton.

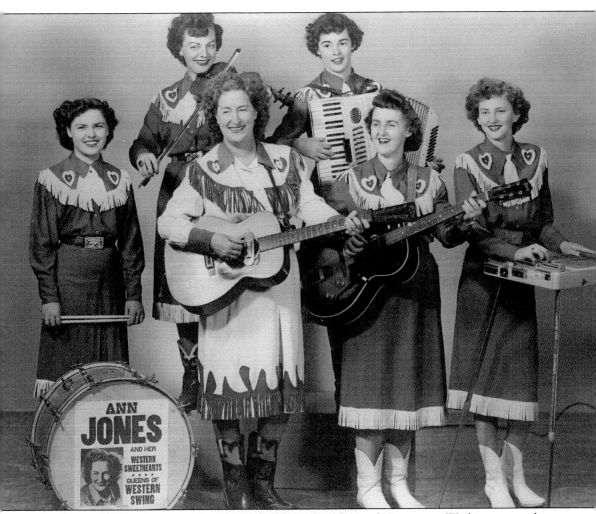

For a good while, the Ann Jones String Band was based out of Vancouver, Washington, and in the 1950s, the all-cowgirl combo enjoyed a recording contract with the big-time Cincinnati-based King Records label.

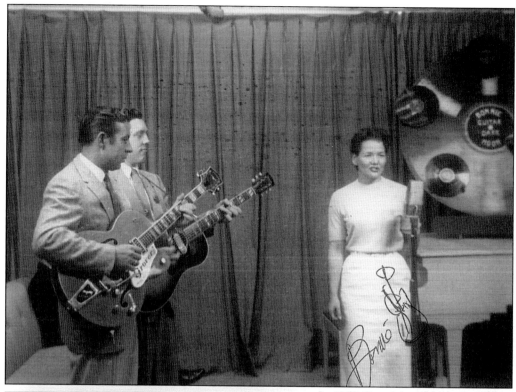

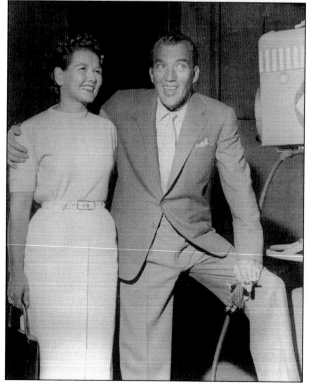

In 1957, Seattle's top country/pop singer Bonnie Guitar promoted her new 45, "Dark Moon," in Tacoma on Bill Wiley and Grover Jackson's KMO-TV program, the *Bill and Grover Show*. (Courtesy Jeff Miller.)

When "Dark Moon" became a national, Top-10 radio hit, Bonnie Guitar began a concert tour with the Everly Brothers and Gene Vincent and even made an appearance in New York City on CBS-TV's *Ed Sullivan Show*. (Courtesy Bonnie Guitar.)

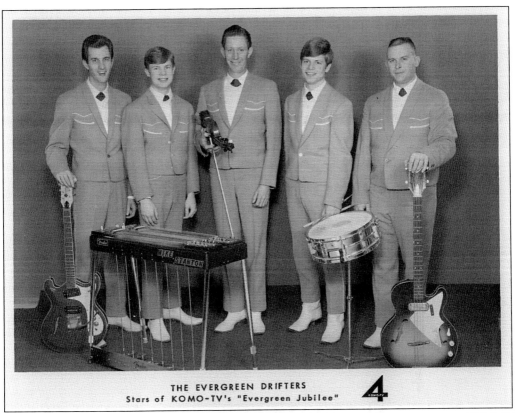

THE EVERGREEN DRIFTERS
Stars of KOMO-TV's "Evergreen Jubilee"

In 1954, Jack Roberts and the Evergreen Drifters took on a regular gig at Heiser's Shadow Lake Ballroom near Renton. In 1962, they began hosting KOMO-TV's *Evergreen Jubilee* country show and in 1964 settled in at the Spanish Castle Ballroom.

In 1957, Jimmie Rodgers—a young folksinger from Camas who'd worked the region's logging camps—scored with the No. 1 smash, "Honeycomb" (the first in a string of 25 international hits including "Secretly" and "Are You Really Mine?"), and from 1959 to 1969, he hosted NBC-TV's *Jimmie Rodgers Show.*

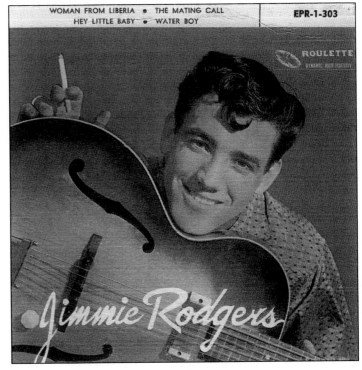

WOMAN FROM LIBERIA ● THE MATING CALL
HEY LITTLE BABY ● WATER BOY

EPR-1-303

ROULETTE
DYNAMIC HIGH FIDELITY

Jimmie Rodgers

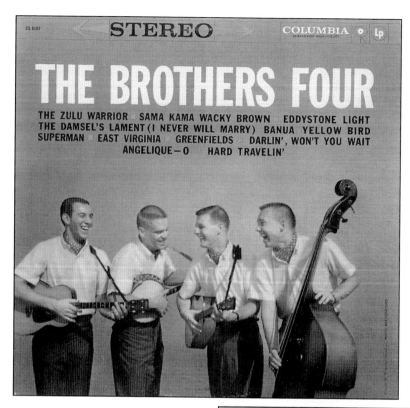

In the fall of 1958, four fraternity brothers from the University of Washington's Phi Gamma Delta house formed the folk group the Brothers Four. Their debut 45 with Columbia Records, "Greenfields," became a No. 2 national hit in 1960—their first of about six hits up through 1965.

The Driftwood Singers were a fine folk trio that helped host KING-TV's *Seattle Center Hootenanny* show in 1962. Billy Roberts (left) is best remembered for his immortal tune "Hey Joe," while Steve Lalor (right) went on to form Seattle's folk rock pioneers, the Daily Flash (see page 99). Lynn Shepard is pictured in the center. (Courtesy Steve Lalor.)

Three

JACKSON STREET JAZZ

Although Seattle's African American community had thrown dances as far back as 1890 with ensembles like the Seattle String Band and the Red Comet Band, the first actual homegrown jazz event likely occurred on the night of June 10, 1918, when Miss Lillian Smith's Jazz Band played an NAACP Grand Benefit Ball at the Washington Hall, 153 Fourteenth Avenue.

By the Roaring Twenties, prominent local black bands, including Edythe Turnham and Her Knights of Syncopation and the Garfield Ramblers, were active. Then, over the next few years, a now-legendary scene comprised of scores of jazz dives scattered along South Jackson Street arose and nurtured many fine musicians. In fact, this underground scene—one that was ignored by the mainstream media, the white majority's segregated musicians labor union (American Federation of Musicians Local No. 76), and the local recording industry alike—was so red-hot that many top outsiders (including the famous jazzbo Ferdinand "Jelly Roll" Morton) loved visiting here to perform.

Among the more notable immigrants was a blind teenaged African American pianist named Ray Charles Robinson who, in March 1948, arrived in town via a long Trailways bus ride from Florida. Immediately embraced by the town's vibrant jazz scene—a musical community anchored by the Negro Musicians Union (AFM Local No. 493), which now included such luminaries as Quincy Jones, Ernestine Anderson, Elmer Gill, Patti Bown, and Merceedees—the newcomer quickly formed the Maxin Trio and scored a regular, income-producing nightclub gig.

Soon thereafter, the Maxin Trio was discovered by a visiting Los Angeles–based record executive who rushed them into a recording session (probably held at the downtown studios of radio station KOL). The resultant 78-rpm disc, "Confession Blues," as issued by the Down Beat label, marked the recording debut for the soon-to-be-famous "Genius of Soul" Ray Charles. It was also his ticket out of town and into the national spotlight.

Most importantly, the overnight success that Ray Charles experienced, and the fact that a locally recorded disc had for the first time ever made a bit of a national splash, seemed to impress a lot of locals who suddenly saw hope that other local talents might duplicate the success.

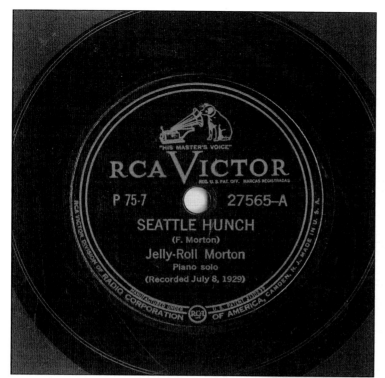

In 1919, the pioneering jazz pianist Jelly Roll Morton arrived in the Northwest to play various brothels and speakeasies like Seattle's Entertainers Cabaret, 1238 Main Street. Legend holds that he faced troubles after losing big at gambling, acted on a hunch to flee, and then recorded a boogie-woogie classic "Seattle Hunch" to mark the occasion.

Brink and Camp were an early vaudevillian duo that composed and performed ragtime jazz novelties like "The Rag With No Name," which was published in 1911 by Warren Camp's Seattle and Los Angeles–based sheet music firm.

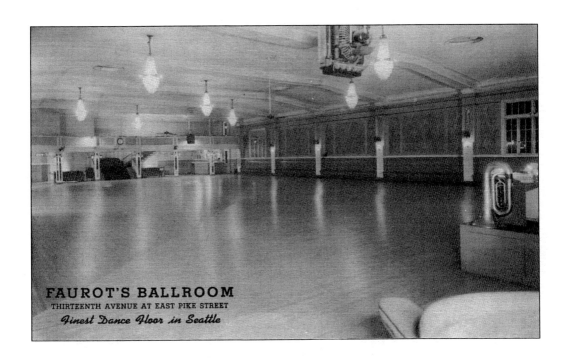

FAUROT'S BALLROOM
THIRTEENTH AVENUE AT EAST PIKE STREET
Finest Dance Floor in Seattle

One of Seattle's first African American jazz bands, the Garfield Ramblers, was formed in 1926 and named for the local high school its members attended. By 1931, trumpeter Jimmy Adams was leading his own band at Faurot's Ballroom at Thirteenth Avenue and East Pike Street. This advertising card for Adams's necessarily versatile band reveals the sociocultural boundary between established "legitimate" music and the wilder sounds of "jazz."

Phone Elliott 2837

Adams' Orchestra

LIBERTY BUILDING
Opposite Post-office

THE VERY BEST ═ JAZZ or LEGITIMATE

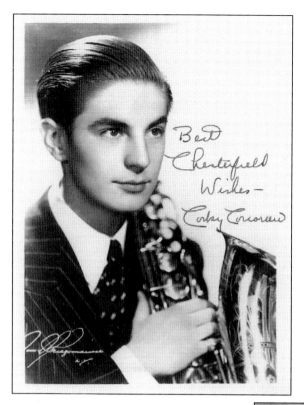

Around 1939, the gifted 15-year-old swing musician Corky Corcoran was discovered in his hometown of Tacoma and hired away by the famed African American bandleader Jimmie Lunceford. By 1941, he was playing with the great Harry James Orchestra, who hosted NBC's *Chesterfield Supper Club* national radio show, and by 1944, *down beat* magazine's readers' poll acknowledged Corcoran in the Top-10 Best Tenor Saxophone category.

Among the local talents who hosted shows around 1949 on Seattle's first television station, KRSC, was Merceedees (Welcker), a winsome pianist who was known for stomping her foot while playing and singing her songs like "The Craziest Thing I Do" and "Please, Baby Be Mine."

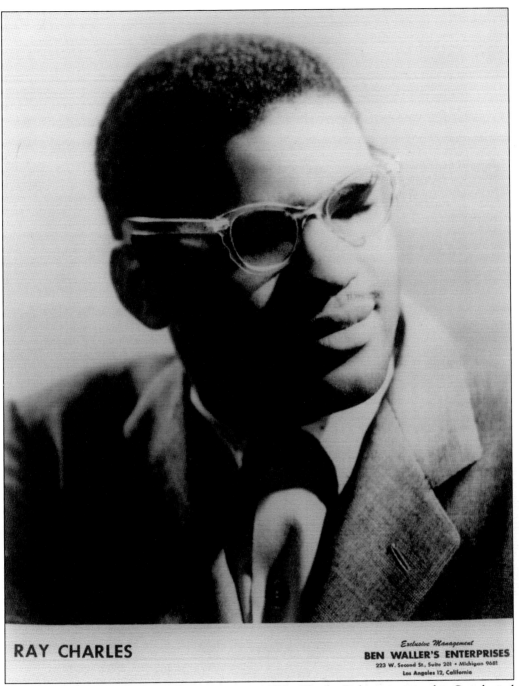

RAY CHARLES

In March 1948, a blind teenaged musician named Ray Charles Robinson arrived in Seattle and stunned the Jackson Street jazz scene. Discovered by a visiting Los Angeles record executive, he was whisked into a radio station studio where his combo, the Maxin Trio, cut "Confession Blues" and "I Love You, I Love You."

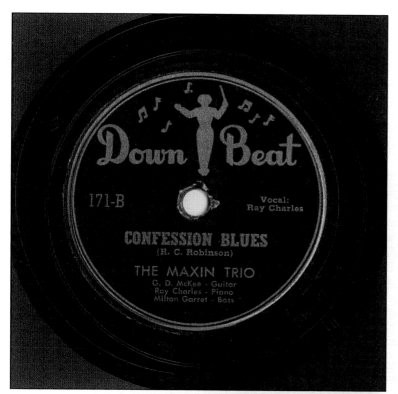

The Maxin Trio's ultrarare 78-rpm disc was not only the debut recording for future soul music superstar Ray Charles, it was also Seattle's first bluesy record. Their follow-up 78 was "Rocking Chair Blues," a tune written in tribute to the nightclub of that name located at 1301 East Yesler Street.

Trade Tokens were privately produced even though they were considered legal substitutes for official coins. Today they are rather rare artifacts because they were originally intended only for local use within a particular business establishment, such as Seattle's Old Rocking Chair nightclub.

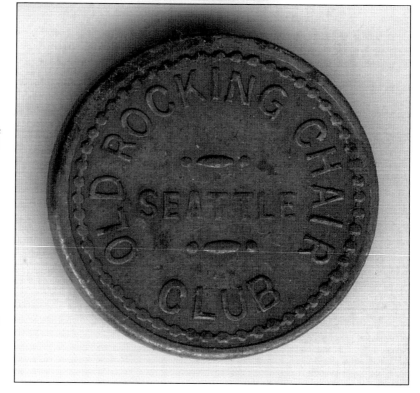

EAGLES TEMPLE,
Aerie No. 1, 708 Union Street, Seattle, Washington

Seattle's Fraternal Order of Eagles built their grand hall on the former site (700 Union Street) of Dreamland in 1923, and its rental ballroom would be the site of legendary concerts ranging from Billie Holiday (with Seattle's Bumps Blackwell Band in 1949), to Los Angeles rhythm and blues singer Richard Berry first bringing his "Louie Louie" to town in 1957, to the Doors blowing minds in 1967, to Iggy Pop's riotous show in 1983 that led to lawsuits and a ban on his return.

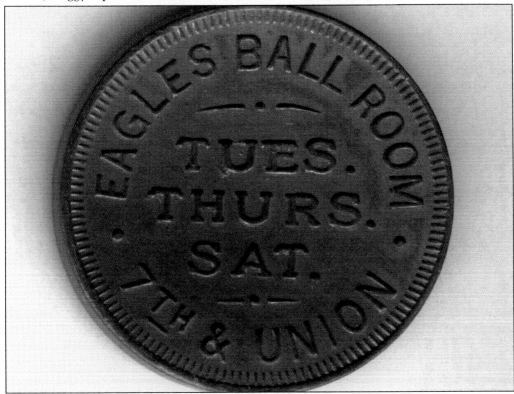

In 1948, Seattle teen singer Ernestine Anderson was discovered and hired away by the jazz icon Lionel Hampton. In 1958, she was touted by *Time* magazine as "the best new voice in the business," and *down beat* magazine dubbed Anderson the "New Vocal Star of '59." Anderson went on to cut over a dozen albums and win many more accolades over the decades.

Patti Bown studied piano uptown at the University of Washington and Cornish School and in the lowdown jazz clubs of the Jackson Street jazz scene. In 1958, Seattle's jazz star Quincy Jones helped her get noticed and signed to Columbia Records where she cut two fine albums.

In 1950, Seattle's Cecil Young Quartet made their debut at the New Chinatown at Sixth Avenue and Main Street, and the town's jazz crowd was stunned to hear such hot bebop music being played locally. Before long, Sid Nathan (the owner of Cincinnati's big-time King Records label) passed through hoping to find Ray Charles, who had already left for California. Instead, Nathan released the foursome's ultrarare *A Concert of Cool Jazz* disc, which was recorded live on June 10, 1951, at Seattle's Metropolitan Theater at Fourth Avenue and University Street. Never to return after a national tour, the quartet's exciting reign in Seattle has been called the "last hurrah for Jackson Street."

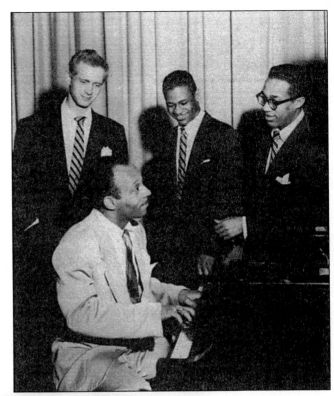

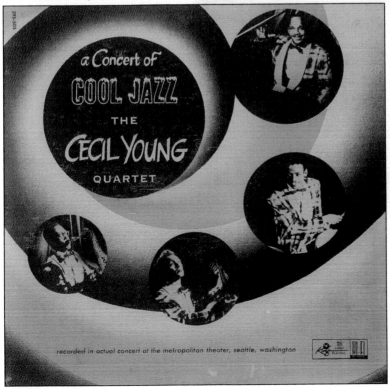

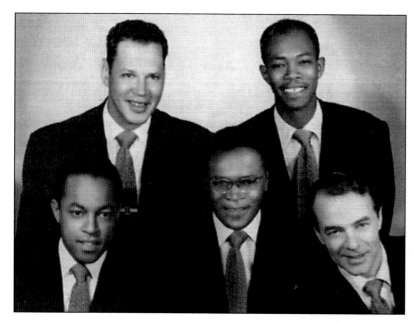

The Question Marks were a trailblazing, multiracial, early-1950s jazz combo that featured famed pianist Elmer Gill (center) and a fine sax man, Bob Braxton, (left) of whom *Billboard* magazine once noted that his "billing as 'Seattle's Billy Eckstein' is not unwarranted."

For 34 years, Seattle's music biz was racially segregated; the white's union (AFM No. 76) hoarded the lucrative downtown jobs, and the black's union (AFM No. 493) made do with gigs in bars along Jackson Street and East Madison Street. Until the two merged in 1958, No. 493 was based at 1319 East Jefferson Street.

Four

ROCK 'N' ROLL ROOTS

Rock 'n' roll music first emerged at just about the exact moment in history when racial relations and civil rights issues were fast coming to a head in America. And the sociopolitical situation in Seattle was a perfect microcosm of this cultural reality. The hidden backdrop behind much of this story is that Seattle's white player's labor union, the American Federation of Musicians (AFM) Local No. 76, had never welcomed the town's many African American musicians, and that slight eventually motivated them to form their own "negro musicians union," AFM Local No. 493.

The result was a multi-decade societal wound that would not begin healing until the two segregated organizations finally and formally merged in 1958. But in the meantime, a few Seattle nightclubs—like the Black and Tan (404 1/2 Twelfth Avenue S) and Birdland (2203 East Madison Street)—had created tolerant spaces where the races mingled, and a few bands soon became popular on both ends of town. Of these, the single most important homegrown 1950s band in the Pacific Northwest was the Dave Lewis Combo. In 1955, Lewis began singing with a teenaged Seattle African American doo-wop group, the Five Checks. By 1956, he was playing piano in the Dave Lewis Combo, a group billed as "The Northwest's Greatest Rock 'n' Roll Band," and in 1957, they became the house band at Birdland.

That summer, the Dave Lewis Combo began playing before nearly all-white audiences while touring the whole state opening up exciting shows for rockabilly pioneers Bill Haley and his Comets. Following in Haley's wake came all the other major touring rock 'n' roll, including Little Richard, Fats Domino, Elvis Presley, Gene Vincent, Eddie Cochran, Jerry Lee Lewis, Ritchie Valens, and Buddy Holly and the Crickets. And duly impressed by all this talent, quite a few local rockabilly bands, including Centralia's Clayton Watson and the Silhouettes (who loved the Dave Lewis Combo even more than they did Haley's Comets), Spokane's Bobby Wayne and the Warriors, Tacoma's Volk Brothers, and Stanwood's Maddy Brothers, formed and cut hip 45-rpm records, but none managed to win the support of area stations and score radio hits.

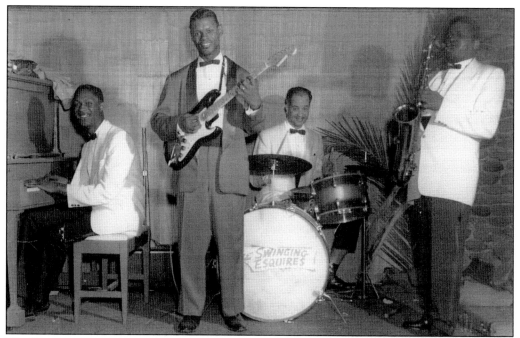

The Swinging Esquires were but one of the numerous African American bands that performed in Tacoma's notorious Lower Broadway area's nightclubs that catered to the soldiers based at nearby Fort Lewis in the 1950s. (Courtesy Jeff Miller.)

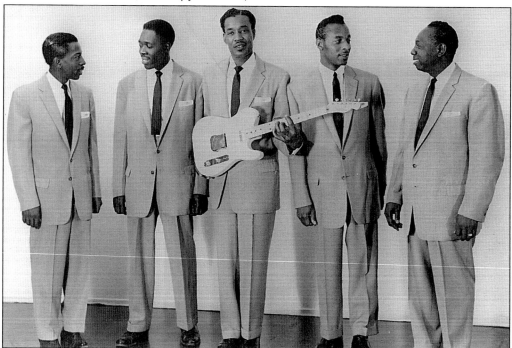

One of Seattle's finest gospel groups in the 1950s was the Southwinds who recorded a number of excellent tunes with the pioneering pop/jazz label Celestial Records. (Courtesy Celestial Records.)

The Southwinds eventually added a red-hot, gravelly voiced singer named Joe Boot and renamed themselves the Fabulous Winds. One of their next recording sessions at Chet Noland's Dimensional Sounds studio (2128 Third Avenue) brought a visit by Boot's old Georgia pal Little Richard and yielded the town's first ever rock single—the 1958 Celestial Records release "Rock And Roll Radio"/"That's Tough." (Courtesy Celestial Records.)

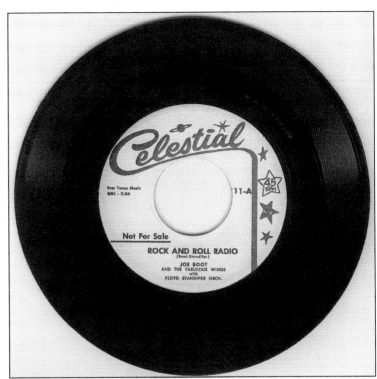

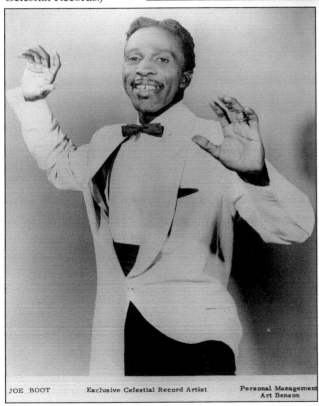

JOE BOOT Exclusive Celestial Record Artist Personal Management
 Art Benson

The Dave Lewis Combo was the most influential 1950s teenaged R&B band in Seattle, opening local shows for touring stars like Bill Haley and his Comets in 1956 and getting hired in 1957 as the house band at the Birdland dance hall. (Courtesy Dave Lewis.)

Opening in 1955 on the former site of the Savoy Ballroom, the Birdland dance hall (2203 East Madison Street) continued presenting jazz and early R&B shows to a racially mixed audience. National stars like James Brown, Big Jay McNeely, and Bill Doggett performed here, as did the bands of local musicians, including Dave Lewis, Ron Holden, and a very young Jimmy (later Jimi) Hendrix. (Courtesy University of Washington Libraries, Special Collections, UW18092.)

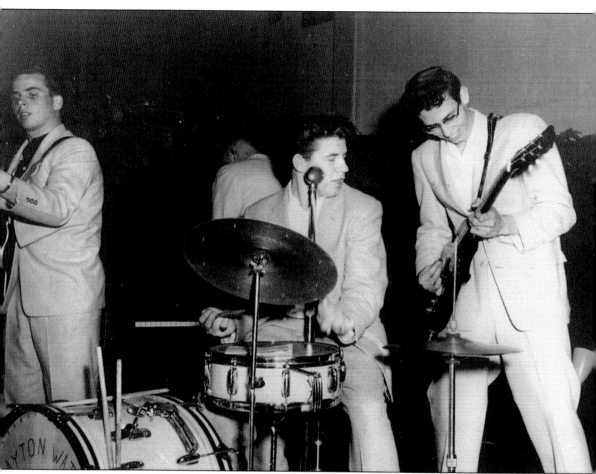

Inspired by Bill Haley's 1956 tours, Centralia drummer Clayton Watson formed his own rockabilly band. In April 1958, the Silhouettes recorded what was likely the Northwest's first rockabilly 45, "Everybody Boppin,' " which they issued on their own Lavender Records label. (Courtesy Jeff Miller.)

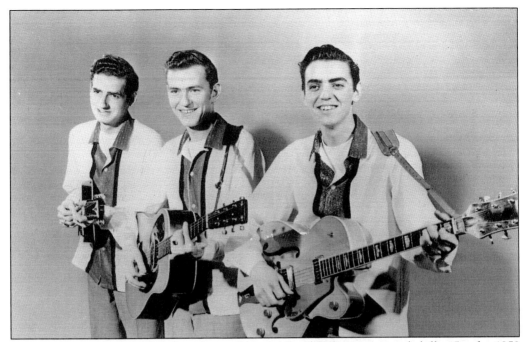

Stanwood's Maddy Brothers were among the very first locals to cut a rockabilly 45—the 1958 single "Rockin' Party," which was issued by Seattle's Celestial Records. For a couple-year period, the boppin' trio—Bob (mandolin), Jim (rhythm guitar), and Tom (lead guitar)—also made weekly appearances on KOMO-TV's *Evergreen Jubilee* show.

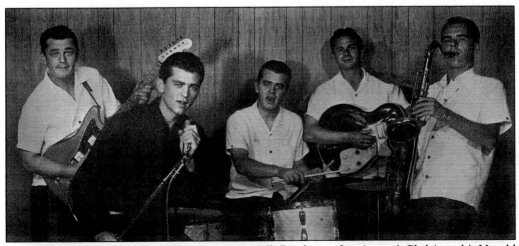

From the 1950s and into the 1960s, Tacoma's Volk Brothers—Jim (guitar), Phil (vocals), Harold Esterbrook (sax), Pat (drums), and Val (rhythm guitar)—cut a number of great rockabilly discs, including "Spring Time Rock" and "There'll Be A Rockin' Party Tonight."

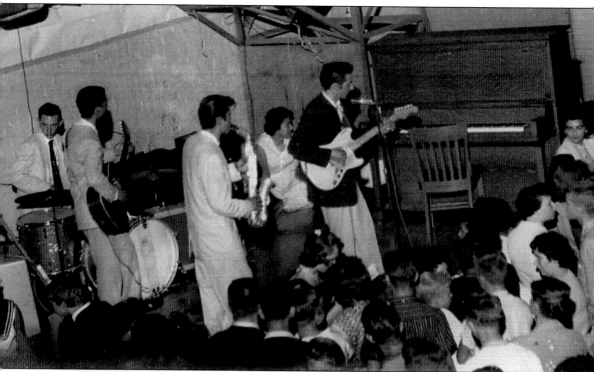

On June 12, 1958, local rockers Jerry Merritt and the Pacers opened a dance at the Yakima Armory headlined by touring rockabilly stars Gene Vincent and his Blue Caps—a band that soon hired him. Merritt cut Capitol Records' *Crazy Times* LP with Vincent, who also recorded the guitarist's compositions, "Hurtin' For You Baby," "She She Little Sheila," and "Born To Be A Rolling Stone." (Courtesy photographer Liggett Taylor.)

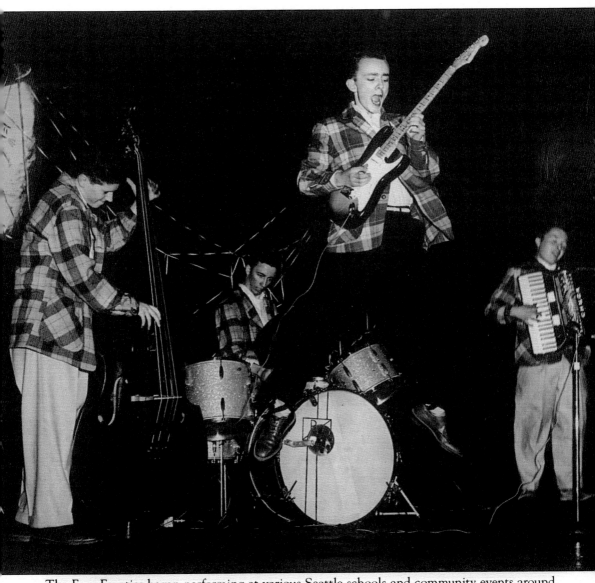

The Four Frantics began performing at various Seattle schools and community events around 1955. Here the band's ace guitarist Ron Peterson jump-starts a 1950s Halloween sock-hop party. (Courtesy Ron Peterson.)

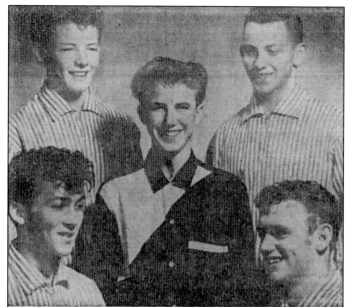

As Tacoma's first all-white teenaged rockin' rhythm and blues band, the Blue Notes were thoroughly befuddling to a stodgy local newspaper that described them variously as "Thrill Jive Addicts" and a "modern jazz" band.

THRILL JIVE ADDICTS—"The Blue Notes," Pierce County's candidates for the hall of fame in the field of modern jazz, are featured at the Crescent ballroom every Friday night. The four instrumentalists, who thrill the younger set as Elvis Presley thrills them with his vocals, are: upper row, Buck Ormsby and Frank Dutra; lower row; Lassie Anes and Billy Engelhart. Pictured center is Robin Roberts, vocalist.

The Blue Notes often played at the Midland Ballroom near Puyallup and occasionally (as seen here) in Tacoma on KMO-TV's weekly variety program the *Bill and Grover Show.*

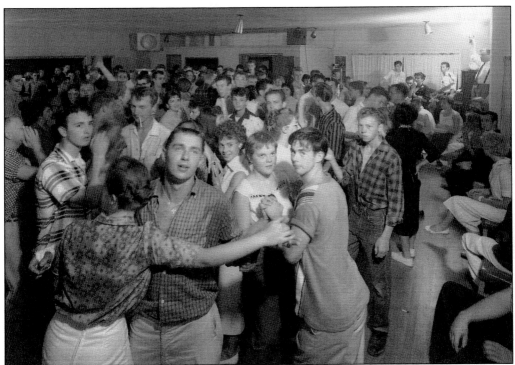

After the Tacoma police demanded a halt to a raucous Blue Notes dance and singer Rockin' Robin Roberts kicked off a long version of "Louie Louie," the band was banned from playing within city limits. On July 18, 1958, they performed just outside town at the Little J. E. M. Cafe. A close-up of the Blue Notes pausing between songs shows, from left to right, drummer Lassie Aanes, guitarist "Little" Bill Engelhart (seated directly behind Roberts), Robin Roberts, and sax-man Frank Dutra. (Both courtesy Tacoma Public Library, Richards Studio Collection, A115654-2B.)

The Checkers were one of the Yakima Valley's very first rock bands, and this original 1950s lineup included the Torres brothers. (Courtesy Mike Metko.)

The Checkers shifted personnel a bit, and this 1959–1960 lineup included Richland's guitar wunderkind and future international jazz star Larry Coryell (at right, next to pianist Mike Mandel). (Courtesy Mike Metko.)

Five

THE BIG BREAKTHROUGH

It was in 1959 that a new Seattle label, Dolton Records—a partnership between some Seattle record wholesalers, their promotions manager Bob Reisdorff, and Seattle's singing star Bonnie Guitar—almost single-handedly exploded the long-standing conventional wisdom that the Northwest could not produce hits. Dolton discovered a promising Olympia teen trio, the Fleetwoods, with a charming ditty, "Come Softly to Me," that they cut in the West Seattle home studio of hobbyist sound engineer Joe Boles. Reisdorff worked his radio industry connections, and within mere days, the record was rocketing into international No. 1 chart status.

The Northwest's malaise had finally been defeated. Everyone could now see that local musicians working in a local studio with a locally written song issued by a local label could in fact sell. But Dolton was only getting started. In May, their second release "Straight Flush" by Seattle's Frantics entered *Billboard* magazine's Hot-100 chart; then the Fleetwoods scored a Top-40 hit with "Graduation's Here." In June, Little Bill and the Bluenotes' gem "I Love an Angel" went Hot-100, and in September, the Fleetwoods' "Mr. Blue" hit No. 1, while the Frantics' "Fogcutter" also went Hot-100.

The momentum continued when other local labels popped up, issued local radio hits, and negotiated national distribution deals with bigger, outside labels. In 1959, Seattle's Penguin Records got the Dynamics' "Aces Up" reissued by New York's Guaranteed Records and the Continentals' "Soap Sudz" reissued by Hollywood's Era Records. In 1960, Seattle's Nite Owl Records saw their singles by the Gallahads and Ron Holden both pushed to hit status by Hollywood's sister labels, Del-Fi and Donna.

Also, in 1960, the Fleetwoods scored three more hits, the Frantics' got their third Hot-100 single, and Dolton struck again with "Walk—Don't Run," a international No. 2 hit that launched the career of the world's most successful instrumental rock band, the Ventures. Dolton went on to release many 45s and LPs, and the label served as a wonderful role model for other enterprising locals, but ultimately its extreme success was its undoing. After relocating to Los Angeles in 1961, the firm lost its focus and eventually fizzled away.

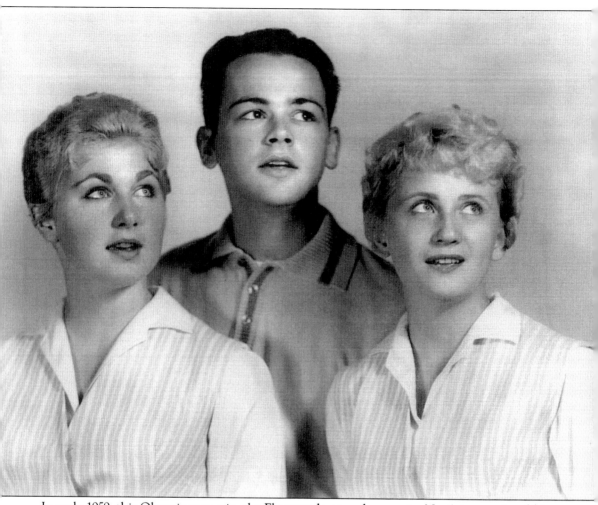

In early 1959, this Olympia teen trio, the Fleetwoods, scored a surprise No. 1 international hit with their "Come Softly To Me" debut doo-wop release for the Northwest's first successful rock label, Dolton Records.

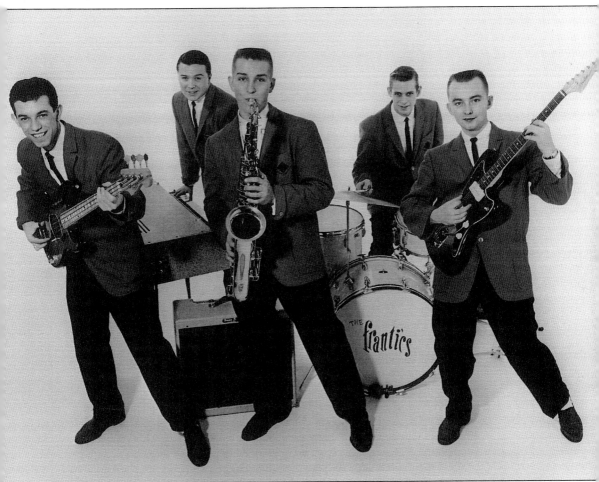

In 1959, Dolton Records signed the Frantics and promptly scored a string of national Hot-100 radio hits ("Straight Flush," "Fogcutter," and "Werewolf") with the distribution help of Hollywood's Liberty Records. (Courtesy Ron Peterson.)

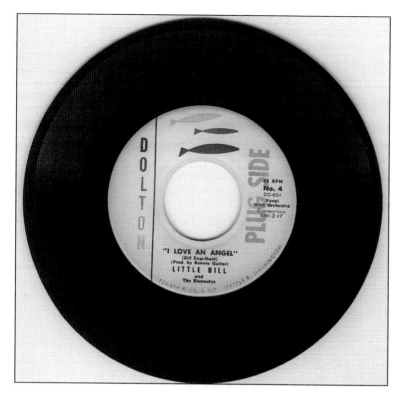

When Dolton Records recast the Blue Notes as "Little Bill and the Bluenotes," and issued Bill Engelhart's "I Love An Angel" around April 1959, two things happened: the 45 hit the national Hot-100, and sidelined singer "Rockin' " Robin Roberts quit.

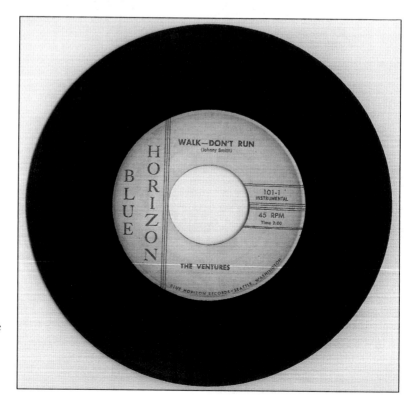

In 1959, Tacoma's Ventures formed their own label, Blue Horizon Records, and issued the now ultrarare "Walk—Don't Run" 45.

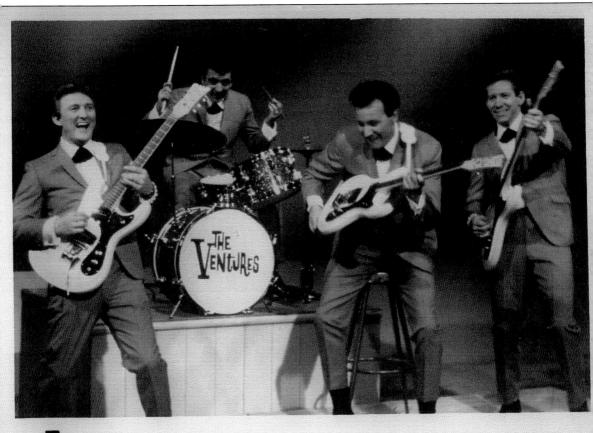

THE VENTURES — DON WILSON · MEL TAYLOR · NOKIE EDWARDS · BOB BOGLE

Exclusive Recording Artists for

DOLTON RECORDS
LOS ANGELES 28 · CALIFORNIA

After breaking out on KJR radio in 1960, "Walk—Don't Run" was rereleased by Dolton Records, becoming a monster international hit that has since been credited with inspiring the whole subsequent Surfer Rock movement. Today the Ventures are recognized as the most influential instrumental rock band in history.

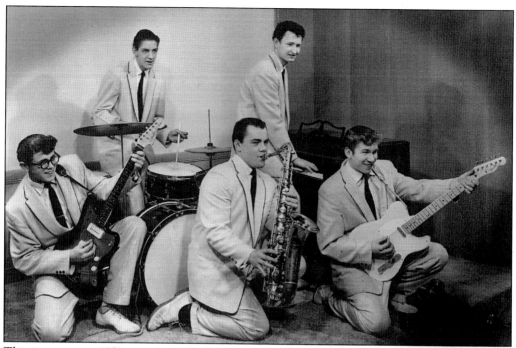

This is a vintage 1959 promotional photograph for Tacoma's pioneering rock 'n' roll band the Wailers, whose debut 45, "Tall Cool One," became a national Top-40 hit for New York's Golden Crest Records. (Photography by Richards Studio, Tacoma.)

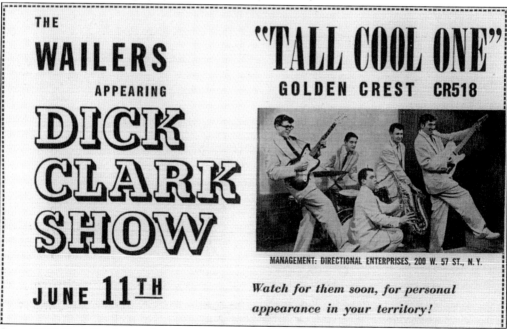

THE **WAILERS** APPEARING **DICK CLARK SHOW** JUNE **11**TH

"TALL COOL ONE" GOLDEN CREST CR518

MANAGEMENT: DIRECTIONAL ENTERPRISES, 200 W. 57 ST., N.Y.

Watch for them soon, for personal appearance in your territory!

Once "Tall Cool One" went from local radio to the *Billboard* magazine popularity charts in May 1959, Golden Crest called the boys back East to promote the hit. A high point of the tour was the Wailers' appearance on ABC-TV's *Dick Clark Show* on June 11, 1959. From there, the song grew into a hit in nations ranging from Canada, to England, to South Africa.

Ron Holden, son of Seattle jazz pioneer Oscar Holden, helped form one of the town's first rockin' R&B bands, the Playboys. By 1959, he was playing with the Thunderbirds, and they recorded his teen ballad "Love You So" for Seattle's tiny Nite Owl Records.

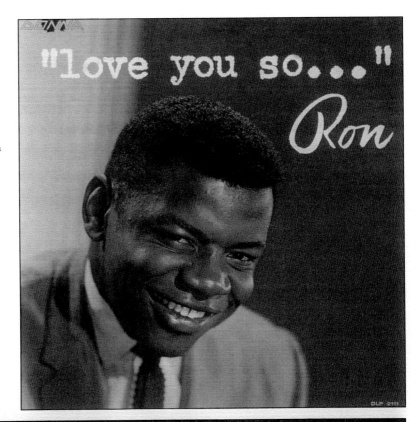

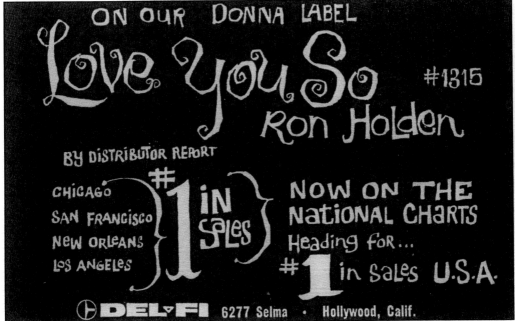

During the summer of 1960, "Love You So" became a strong regional radio hit, and a bigger Hollywood label, Donna Records, stepped in, pushing it into international Top-10 hit status and then released a full-length LP.

Among the best local 1950s doo-wop groups were the Gallahads (seen reunited years later) who recorded for Nite Owl before jumping to the Del-Fi and Donna labels where they scored a minor national hit with "Lonely Guy," which became a West Coast hit and then nearly went national after Dick Clark spun it on his *American Bandstand* television show. (Photography by George Somoff.)

The Swags formed in Bellingham in 1958 and self-released their "Rockin' Matilda" 45 in 1959. After opening a local show for the touring Chicano rock star Richie Valens, his label, Del-Fi Records, rereleased the disc making it a West Coast hit.

Six

THE ORIGINAL
NORTHWEST SOUND

During the period of 1959–1960, outside record firms and radio stations suddenly became far more open to considering music from the Northwest, and that buzz in the business created openings for the opportunistically inclined. Never great supporters of any form of big-beat music in the past, various local television stations suddenly jumped right in that year and began to broadcast sock-hop shows like *Rock 'n' roll Party*, *Seattle Bandstand*, *Yakima Bandstand*, and *Portland Bandstand* that featured area bands. Beyond all that though, as more and more local entrepreneurs formed new labels, signed new bands, and began pushing great records, certain outsiders who'd taken note of all the action began to step in and nab a share of the local rock 'n' roll pie.

That is precisely how Tacoma's Wailers scored their first of many hits and began their long reign on the region's growing teen-dance circuit. It was in the spring of 1959 when agents with the New York City–based Golden Crest Records journeyed out to Lakewood with mobile gear and recorded the Wailers after a dance at the Lakewood Knights of Columbus Hall. That summer saw the guys scoring two instrumental rock hits, the Top-40 winner, "Tall Cool One," and the Hot-100 follow-up, "Mau Mau," and traveling back East to make television appearances on the *Dick Clark Show* and *Allan Freed Show*.

Inspired and energized, local companies like Seafair/Bolo Records, Jerden Records, Lavender Records, Camelot Records, and Etiquette Records began releasing many records by scores of new bands—some of whom were actively forging and codifying a distinct regional strain of instrumental, rocking R&B music that would come to be widely known as the Original Northwest Sound. The aural markers of this provincial musical language often included big melodic riffs, grunting saxes, the oomph of an electric organ, and the sinewy hooks of a blistering guitar—that would dominate local teen dances and indelibly steep the musical sensibilities of its practitioners, including the young guitarist named Jimmy Hendrix who played with a few of Seattle's teenage African American bands, the Velvetones, Rocking Kings, and Thomas and his Tomcats.

In 1961, Dave Lewis formed an organ trio (guitarist Joe Johansen, left, and drummer Dicky Enfield, right) and nailed down a regular gig at Dave Levy's venerable jazz club, Dave's Fifth Avenue (112 Fifth Avenue N), which was located across the street from the 1962 Seattle World's Fair. It was there that Herb Alpert of Tijuana Brass fame discovered and signed them to his new A&M label where they scored a few instrumental radio hits ("David's Mood" and "Little Green Thing"). (Photography by Odell Lee.)

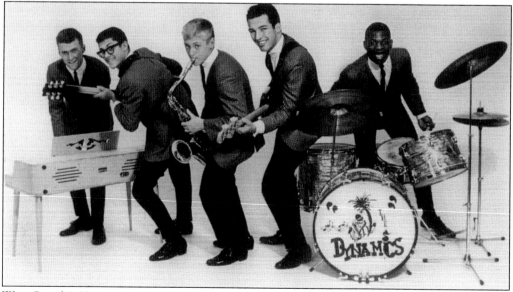

West Seattle's Keynotes originally formed back in 1959. By 1961, and renamed the Dynamics, the band now included ex-Checkers' guitarist Larry Coryell, and they scored their first regional hit with a cover version of Dave Lewis's "J. A. J."

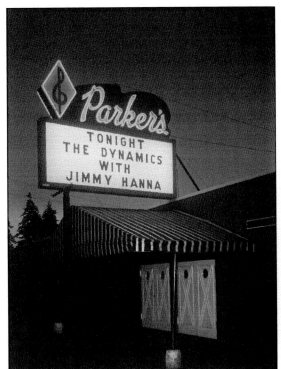

By 1964, the Dynamics featured teen-heartthrob singer Jimmy Hanna and guitarist Harry Wilson, who was recruited to fill in for Larry Coryell (who'd departed to launch a jazz career in New York City). The band ruled Seattle's teen dance scene from Parker's Ballroom where they cut their regional best seller LP. (Photography by Forde Photographers; courtesy Tom and Ellen Ogilvy.)

The Viceroys Five

Formed in 1958 as Vince Valley and the Chain Gang, this band became the Viceroys, and in 1963, their instrumental 45 "Granny's Pad," named after their rehearsal space, became a massive KJR hit and the biggest-selling local-label single yet.

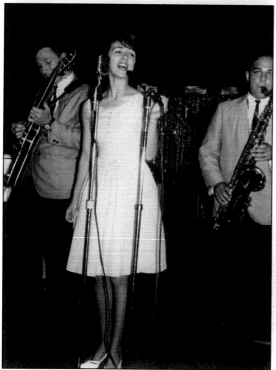

Among the talents who performed with the Viceroys were African American singers (ex-Gallahad member) Jimmy Pipkins and Aaron Stewart, and Nancy Claire (seen here), who had also performed with the Frantics, Dynamics, Ventures, and Adventurers. (Courtesy Nancy Claire.)

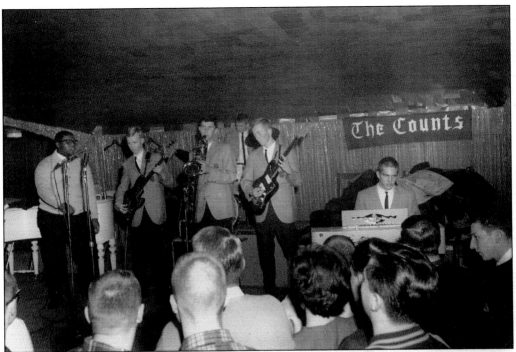

Several Ballard High School pals formed the Counts in 1959, and in 1964, their "Turn on Song" became a huge KJR hit and also was a standard for many other local teen R&B bands. This vintage promotional photograph includes singer "Tiny" Tony Smith. (Photography by Peter Riches.)

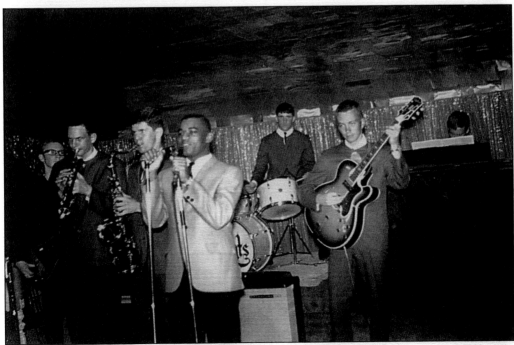

Other African American singers who performed at teen dances with the Counts were Seattle's Woody Carr and, as seen here, Billy Burns. (Courtesy Gayle Russell.)

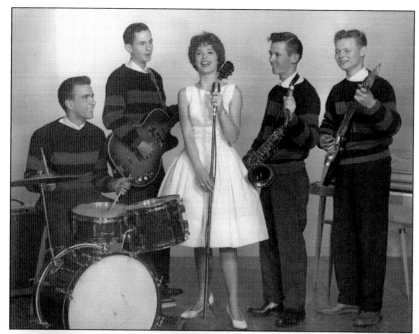

Soon after Renton's Aztecs added a new young singer named Merrilee Gunst in 1960, the band broke up with she and sax-man (and future husband), Neil Rush, quickly forming Merrilee and Her Men, seen here. (Courtesy Merrilee Rush.)

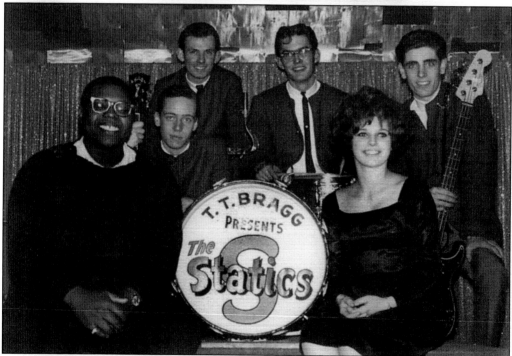

The year 1960 also saw the Statics forming in Burien, and by 1962, they'd added Merrilee and Neil Rush and former doo-wop singer for the Gallahads Tiny Tony Smith. They scored a big regional radio hit "Hey, Mrs. Jones," for Seattle's Bolo Records. Seen at Parker's Ballroom, the Statics were also one of the local combos who performed outdoors on the International Bandstand for the 1962 World's Fair's Dance Under The Stars events on Saturday nights that summer. (Courtesy Merrilee Rush.)

Seven

THE "LOUIE LOUIE" CRAZE

It was 1961 when the Wailers and their new singer Rockin' Robin Roberts launched their own independent company, Etiquette Records, with a remarkable No. 1 regional radio hit. It was a rock 'n' roll version of "Louie Louie," that obscure 1957 R&B gem written by the Los Angeles–based singer Richard Berry. Then, during the giddy opening weeks of the 1962 Seattle World's Fair, the Wailers' 45 topped the local charts once again.

Problem was, for all its local success, the Wailers just could not get any industry big-wigs to take the tune seriously and step up with a distribution deal that would make the song a nationwide smash. Even KJR kingpin Pat O'Day pled the case with Hollywood record execs, but by the time Liberty Records finally agreed to help, it was too late.

But then, in 1963, two Portland-based combos, the Kingsmen and Paul Revere and the Raiders, found themselves locked into a summer-long duel with their new "Louie Louie" 45s pitted against each other on rival radio stations. The Raiders sold enough to get themselves signed as the first-ever rock 'n' roll band on the major label, Columbia Records, while the Kingsmen's version fell from the charts, and the band split up in dismay.

Seattle's Jerden Records continued pushing the Kingsmen's 45 though, and when it broke out on Boston radio, they soon had a national No. 2 hit on their hands. The Kingsmen regrouped—albeit without their original singer, Jack Ely, whose gloriously garbled lyrics would cause a national pornographic lyrics scandal that sparked an FBI investigation—and went on to much fame.

Meanwhile, "Louie Louie" became the signature song of the entire Northwest teen scene. Scores of local bands, including the Thunderbirds, Viceroys, Sonics, and Don and the Goodtimes, recorded versions, but in fact, hundreds of additional bands performed the tune at weekly dances all across the region for years on end—a ritual that eventually spread nationally and then globally, eventually causing the "ultimate party song" to also be touted (after 1,600 different renditions were documented) as the "most recorded song in history."

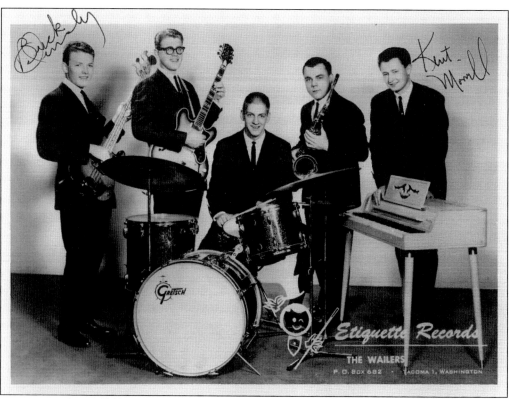

In 1960, the Wailers made a few moves that ensured they would solidify their position as the kings of the Northwest teen dance scene. Inspired by the great touring R&B revues they'd seen in action at the Evergreen Ballroom, the band expanded their show by adding two former Blue Notes, singer Rockin' Robin Roberts and bassist Buck Ormsby; a female singer, Gail Harris; and eventually a trio of female backup singers, the Marshans.

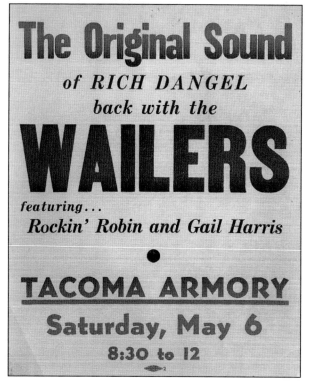

The Original Sound
of *RICH DANGEL*
back with the
WAILERS
featuring...
Rockin' Robin and Gail Harris

●

TACOMA ARMORY
Saturday, May 6
8:30 to 12

In early 1961, the Wailers launched their own label, Etiquette Records, with a 45 of the old R&B song "Louie Louie," which Seattle's KJR radio helped promote into a huge No. 1 regional radio hit, and the local mania for the tune caused hundreds of local bands to incorporate it into their own set-lists.

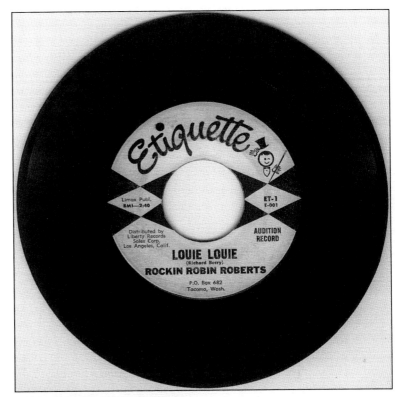

Program director and star DJ Pat O'Day made KJR into one of the most powerful trendsetting stations in the nation. He also built up a huge, regional, teen-dance business and is seen here spinning discs at a 1963 sock hop at Olympia High School. (Photography by Greg Gilbert; courtesy Pat O'Day.)

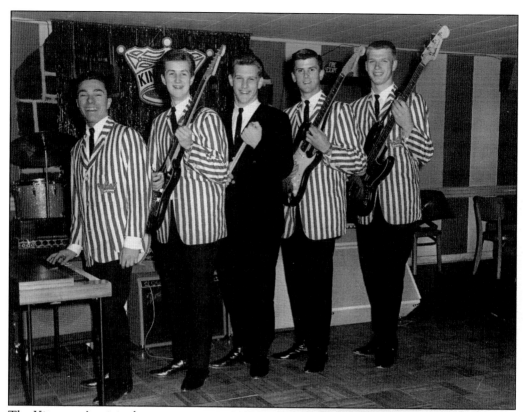

The Kingsmen's original lineup included Don Gallucci (keyboard) and Jack Ely (guitar/vocals). Pictured in 1963 at Portland's teen club the Chase, Ely exited the band just months before their local radio hit, "Louie Louie" (on Seattle's Jerden Records), suddenly exploded into a global smash upon reissue by New York's Wand Records. (Above, photographry by Gino Rossi.)

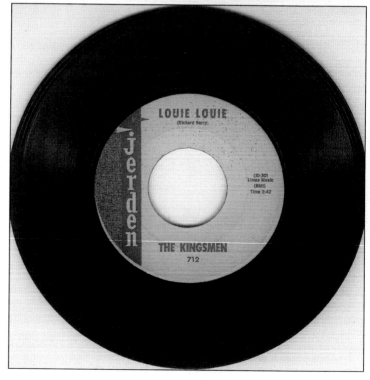

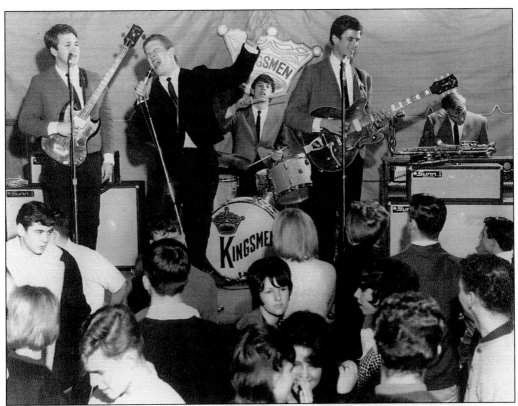

The reconstituted Kingsmen are shown performing live (c. 1964–1965) with former drummer Lynn Eastman now on vocals, Dick Peterson on drums, Norm Sundholm on bass, and Barry Curtis on keyboard. Curtis had been with Yakima's Redcoats in 1958–1959 along with Gary Puckett, who later lead a hit-making band named for the Yakima Valley town of Union Gap.

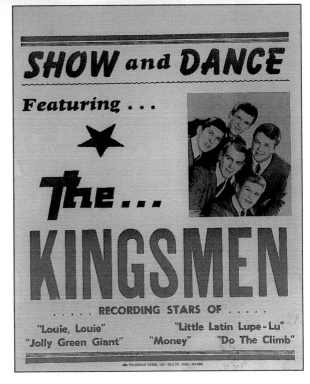

89

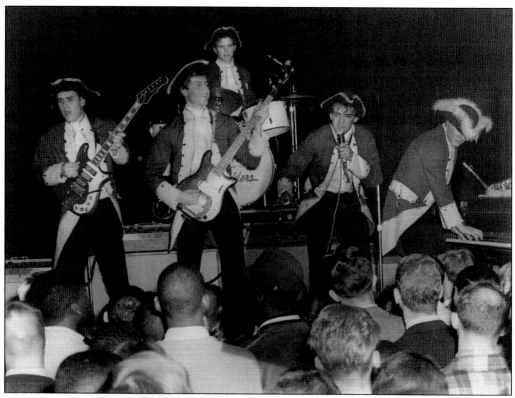

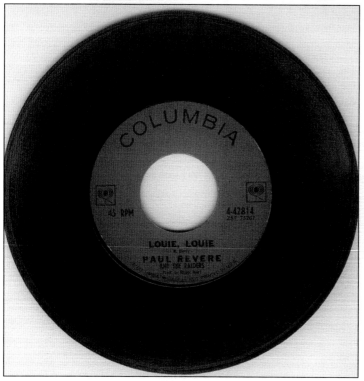

Formed in Idaho as the Downbeats in 1958, Paul Revere and the Raiders scored a national hit in 1961 with "Like Long Hair." In 1962, Revere resettled in Portland, and by 1963, and now clad in their trademark Colonial stage apparel, the band's "Louie Louie" single (as originally issued on Portland's Sande Records) became the minor West Coast hit that got them signed to Columbia Records. Later, in 1966, the Raiders were one of America's top bands and would include former Viceroys' guitarist Jim Valley and former Chancellors' guitarist Phil Volk on bass. (Photography by Mulholland Studios.)

After the Kingsmen's "Louie Louie" hit in late 1963, their ex-singer began performing with Jack Ely and the Courtmen. Forever linked to his infamous vocals on that 45, Ely would go on to cut such knockoffs as "Love That Louie," "Louie Louie '66," and "Louie Go Home."

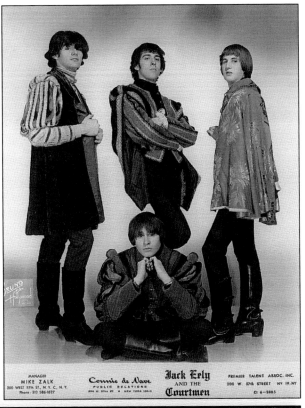

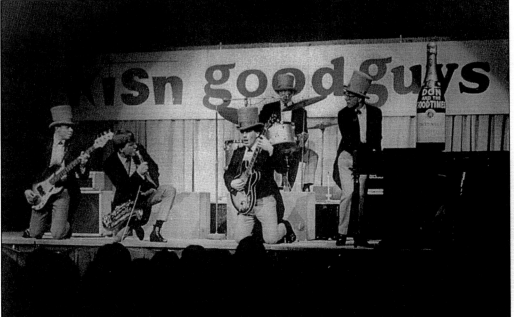

In the wake of the Kingsmen's success, original keyboardist Don Gallucci, being too young to tour, formed a new band in 1964. Don and the Goodtimes became a wildly popular dance draw, and in 1967, they scored two national Hot-100 hits with Epic Records.

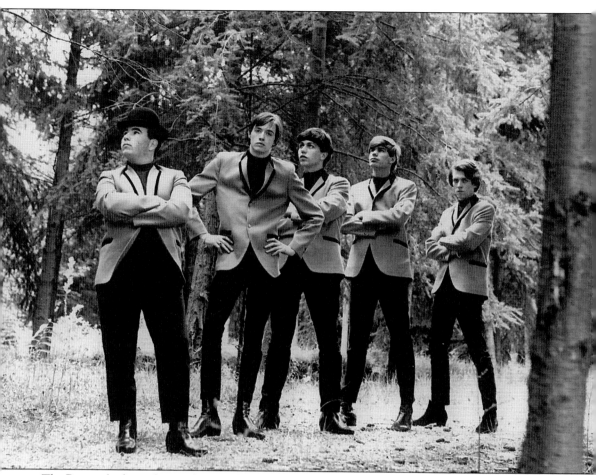

The Raymarks formed around 1964 when members of two other Bremerton bands, the Orbits and Rogues, joined forces. They became a popular dance band, appeared on KING-TV's *Soundstage* and KTVW's *Rock-A-Go-Go*, and cut the great "Louie Louie" tribute 45 "Louise Louise." (Photography by Jini Dellaccio; courtesy Mike Spotts.)

Eight

BATTLES OF THE BANDS

The 1960s saw a great expansion of the Northwest's teen dance circuit. The dance promotion firm run by KJR DJ Pat O'Day was alone throwing an estimated 50 events per week across the state. Then there were the many Battle of the Bands held at skating rinks, high school gyms, National Guard armories, and old roadhouses, and finally there were O'Day's giant multiday Teen Fair and Teen Spectacular fests.

But the flowering of the psychedelic era brought forth trippy hippie bands and a fresh generation of entrepreneurs, including event promoters like Boyd Grafmyre and the Trips-Lansing crew who stepped forward to battle O'Day's hegemony. Additional new factors on the scene were the emerging light show companies (Lux Sit and Union Light Company), confrontational counter-culture publications (the *Helix* and the *Seer*), and venues like the Happening (in the Showbox Theater), the 13th House (1818 Seventh Avenue), and the BFD (1903 Yale Avenue).

The eye-popping light show dances at Seattle's Eagles Hall in the Summer of Love lead to historic, multiday, outdoor rock festivals, like 1968's fabled Sky River Lighter Than Air Fair in Sultan (credited as the direct antecedent to 1969's famous Woodstock Festival) and the Seattle Pop Festival of 1969 in Woodinville, until such unruly gatherings were banned in the early 1970s.

Still, the foundations of the Northwest's once-great scene were crumbling; by 1969, none of the local labels were active, and the radio industry consolidated and was once again rejecting local discs. So the formerly robust teen dance circuit finally withered as the baby boomers and their newfound ability to enter beer joints at age 21 now came to rely on corporate talent agencies (like Far West Entertainment, Unicam, and the Stephan Agency) to book what became known as "tavern bands."

Although these changes may have represented a more efficient business model, a certain element of fun—the idea that anyone could book a band and throw a dance—was somehow lost along the way. With this new balance of power, music would now be all business. For the next few years, it would pay for bands to avoid "rocking the boat" and sadly to also rock the music far less as the mellow 1970s unfolded.

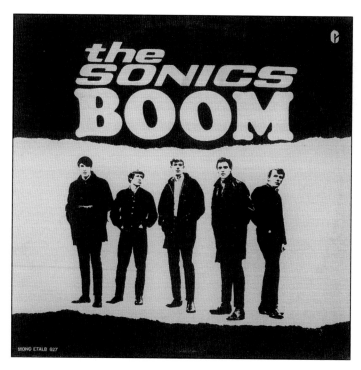

MONO ETALB 027

In 1964, the Sonics blistering, proto-punk single, "The Witch," hit No. 2 on KJR and is now credited with sparking the entire garage-punk movement. In 1966, Etiquette Records issued *The Sonics Boom* LP, which featured tuff music, a classic cover image by renowned local photographer Jini Dellaccio, and a radically stark graphic design by Zane Baker that perfectly captured the Bremerton/Tacoma band's edgy vibe.

Olympia's Evergreen Ballroom (9121 Pacific Avenue SE) was the site of many fabled nights since its founding by Walter Sholund in 1931. Highlights included early shows by legends like Louis Armstrong, Tommy Dorsey, Stan Kenton, Hank Williams, Bill Haley, Fats Domino, the Platters, Jackie Wilson, and local bands like the Wailers and Sonics in the 1960s.

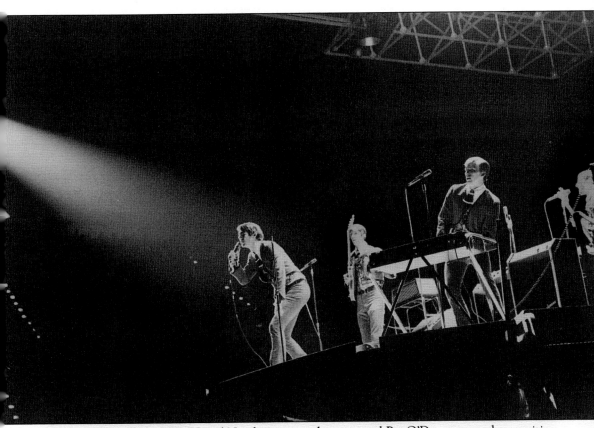

Between 1964–1969, KJR DJ and Northwest teen dance mogul Pat O'Day promoted an exciting series of events billed as Teen Fairs or Teen Spectaculars at the Seattle Center. These shows typically featured booths hawking youth-oriented products (mod clothing, hair care products, musical instruments, etc), a Battle of the Bands contest (the 1965 battle drew 300 young combos!), and concerts featuring headliners such as the Beach Boys, Rolling Stones, and Yardbirds. In addition, top local bands like the Sonics (seen here at the Seattle Center Coliseum on January 30, 1965) also got the chance to perform in the town's biggest venue. The band's hit, "The Witch," was flooring fans with its unprecedented fury, and subsequent numbers like the devilish "He's Waiting" and the toxic "Strychnine" would go on to inspire a global following and various cover versions by outside bands (the Cramps, DMZ, Thee Headcoats, Cynics) and grunge-era Northwest bands (the Screaming Trees, Mono Men, and even the Strychnines, an all-Sonics tribute band comprised of members of Mudhoney, Girl Trouble, U-Men, and the Young Fresh Fellows). (Photography by Jini Dellaccio.)

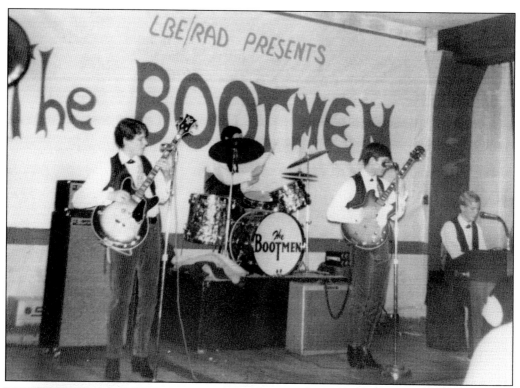

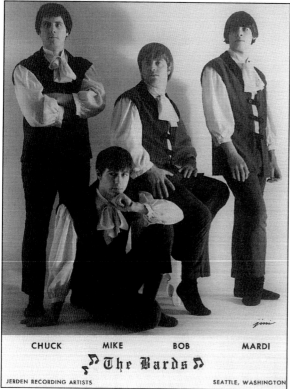

CHUCK MIKE BOB MARDI

♪ The Bards ♪

JERDEN RECORDING ARTISTS SEATTLE, WASHINGTON

In 1963, members of Tacoma's Solitudes and Aberdeen's Capris joined up and formed the Bootmen. After recording the killer garage-rock two-sider "1234"/"Black Widow," sax-man Ron Gardner joined the Wailers and the Bootmen settled in Olympia. (Courtesy Duane McCaslin.)

Formed in 1961 as the Fabulous Continentals, by 1964 this Moses Lake band was gigging as the Bards. In 1967, their "Never Too Much Love" became such a huge local hit that Capitol Records picked it up, and then in 1969, Parrot Records licensed their "Tunesmith" hit. (Photography by Jini Dellaccio.)

Formed in Everett during the high point of the British invasion, which swamped the shores of America from 1964 though 1966, the Mercy Boys competed at Seattle's 1965 Teen Fair Battle of the Bands and recorded three singles, including "Spoonful" (Merrilyn Records) and "Lost and Found" (Panorama Records), before disbanding in 1967. (Photography by Jini Dellaccio.)

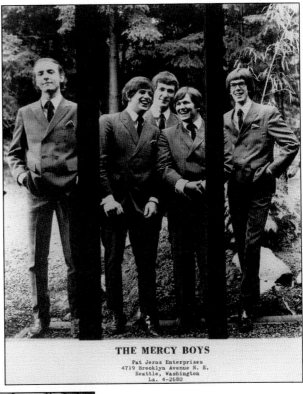

THE MERCY BOYS

Pat Jerns Enterprises
4719 Brooklyn Avenue N. E.
Seattle, Washington
La. 4-2680

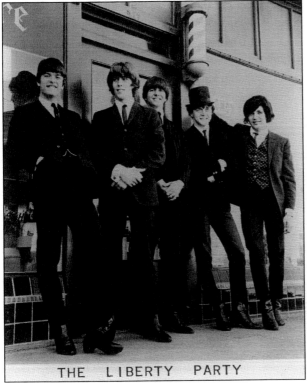

THE LIBERTY PARTY

Originally formed in 1963 as the Enchanters, this band was but one of the many who adopted a British vibe at the height of Beatlemania. Revamped in 1965 as the Liberty Party, the group saw one tune, "Send For Me," issued on the classic *Battle Of The Bands Vol. 1* LP and the 45 "Weep On" issued in 1966.

97

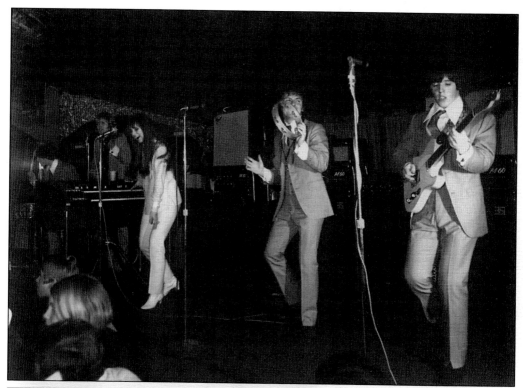

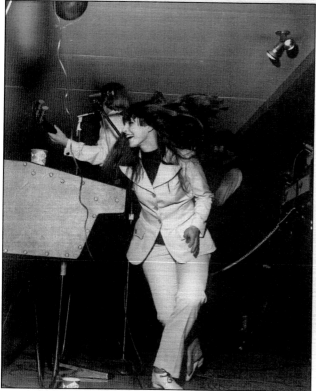

After Merrilee and Neil Rush split from the Statics to form the Turnabouts (seen here at Parker's), the new band became one of Seattle's top dance draws. In 1967, Merrilee joined a national tour opening for Paul Revere and the Raiders, and mid-tour she cut a Top-10 classic, "Angel of the Morning," her first of four national hits. (Courtesy Merrilee Rush.)

Seattle's Merrilee Rush and the Turnabouts perform their impressive synchronized dance steps live at a mid-1960s Northwest teen dance. (Courtesy Merrilee Rush/ Hobart's Photography.)

Seattle's folk-rock heroes, the Daily Flash, debuted in 1965 with their exciting feedback-laced "Jack of Diamonds" 45 on Parrot Records. In California, they shared the bill with Cream, Big Brother, Country Joe, and Van Morrison and cut their second single "French Girl," which became a strong Seattle radio hit and nearly broke out nationally for Uni Records. (Photography by Jini Dellaccio.)

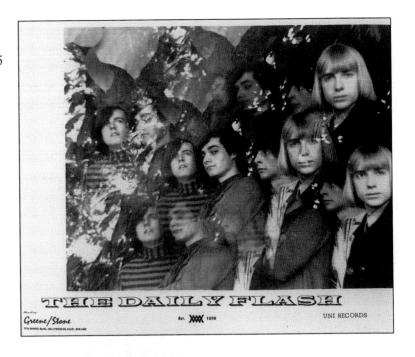

THE DAILY FLASH

Greene/Stone

Est. XXXX 1898

UNI RECORDS

Kathie & the Unusuals

REPRESENTED BY GARRETT ENTERPRISES
314 FAIRVIEW AVENUE NORTH
SEATTLE, WASHINGTON 98109
(AREA CODE 206) MAIN 4-2061

In 1965, the Bellingham Accents morphed into the Unusuals, headed to Haight-Ashbury, and scored a deal with the same label (Mainstream Records) that had Janis Joplin and Big Brother. Singer Kathi McDonald, discovered and hired by Ike Turner, eventually replaced Joplin in Big Brother and later recorded the *Exile on Mainstreet* album with the Rolling Stones.

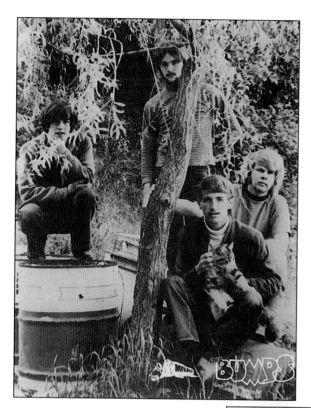

Formed in 1965 by players from Seattle and Monroe, the Bumps played countless dances, competed in the Teen Fair Battle of the Bands, and recorded a number of records, including the psychedelic gem "Please Come Down." (Photography by Bob Greer.)

In 1966, Spokane-based band the Gas Company recorded their "I Couldn't Make Up My Mind" 45. Guitarist Ned Neltner had been in earlier combos—the Redcoats, the Demons, and the Mark V—and would go on to help found Jr. Cadillac.

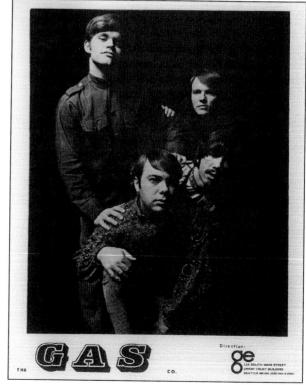

Formed in 1966, Crome Syrcus forged a progressive, psychedelic sound that made them regulars at Seattle's Eagles Hall, took them to San Francisco's Fillmore and Avalon ballrooms, saw their *Love Cycle* LP issued by ABC, and got them booked at both the Sky River Rock Festival and Seattle Pop Festival in 1969.

Seattle's Easy Chair was formed in 1967, and they did shows with the Yardbirds, Cream, and Grateful Dead and performed at the legendary Sky River Rock Festival and Lighter Than Air Fair in August 1968. That same year, the band opened for Frank Zappa, who soon hired bassist Jeff Simmons (right) to join his band. (Courtesy Jeff Simmons.)

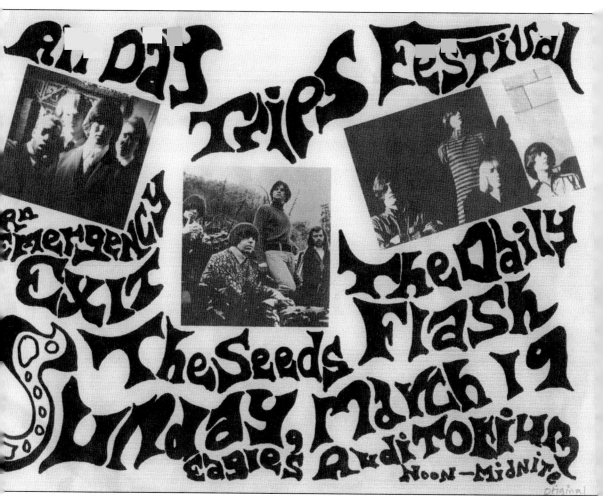

Both Seattle's hippies and curious teenyboppers attended the Trips Festival—a psychedelic light show and multimedia event—on March 19, 1967, at the old Eagles Auditorium. Music was provided by Emergency Exit, the Daily Flash, and a headliner act imported from California, the Seeds, who brought along their new hit, "Pushin' Too Hard." (Photography by Jini Dellaccio.)

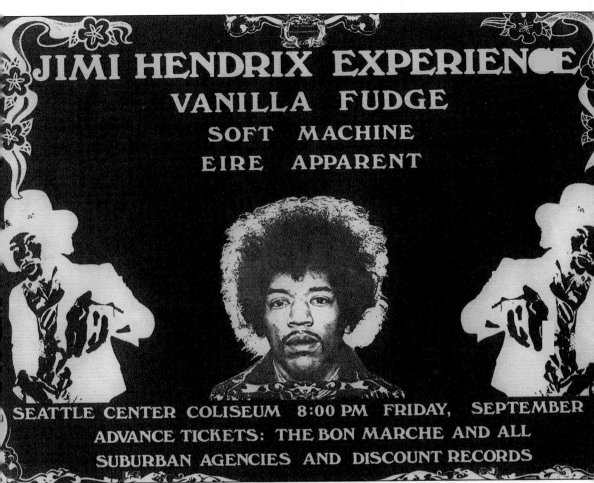

JIMI HENDRIX EXPERIENCE
VANILLA FUDGE
SOFT MACHINE
EIRE APPARENT

SEATTLE CENTER COLISEUM 8:00 PM FRIDAY, SEPTEMBER
ADVANCE TICKETS: THE BON MARCHE AND ALL
SUBURBAN AGENCIES AND DISCOUNT RECORDS

Seattle's Jimi Hendrix—who'd played guitar in local bands on the area's "Louie Louie" scene (1957–1961) before serving in the military, playing in various R&B bands, and finding stardom in London—brought his international hits like "Purple Haze" and his nod to a favorite dance hall "Spanish Castle Magic" to a long-awaited homecoming concert that was promoted by this rare 1968 handbill.

First formed in Spokane as Cold Power in the 1960s, Cheyanne moved to Seattle around 1970 and, after an image update and name change to the more glamorous Shyanne, became a popular draw on the tavern and high school dance circuits.

For much of the 1970s and 1980s, Seattle's Jr. Cadillac was the top Northwest tavern rock band. Their popular oldies orientation reflected the fact that veterans of earlier bands, including the Wailers, Frantics, and Sonics, originally formed Jr. Cadillac.

In the 1970s, Rail was one of the most active bands on the Northwest's high school dance circuit. In 1983, their "Hello" music video won MTV's *Basement Tapes'* contest.

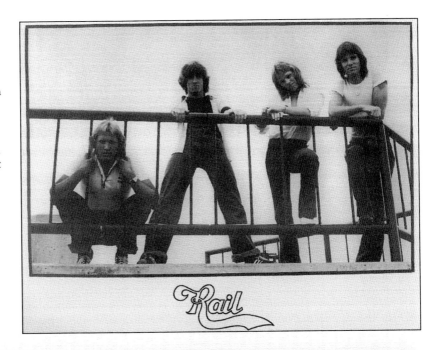

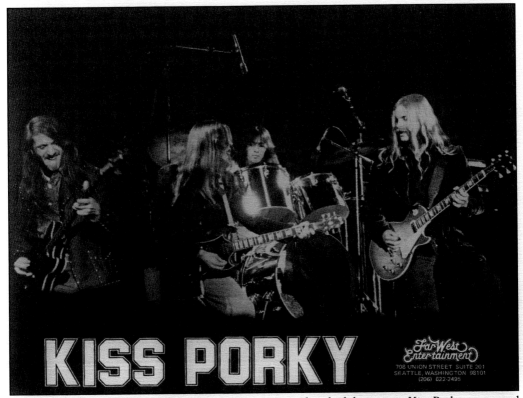

An obscure but impressive Seattle band that was way ahead of their time, Kiss Porky wrote and performed songs that had an attitude and dark esthetic that foreshadowed the subsequent death metal movement. (Courtesy Bruce Kirkman.)

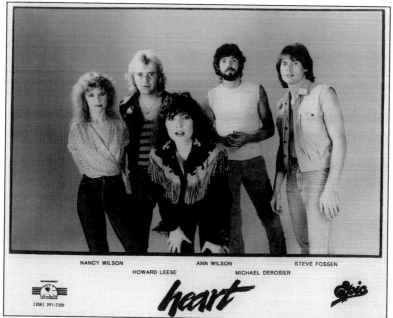

NANCY WILSON ANN WILSON STEVE FOSSEN
HOWARD LEESE MICHAEL DEROSIER

(206) 241-2320

The most commercially successful Northwest band of the 1970s, Heart was a strong draw at the region's biggest taverns for years prior to their first international hits, "Crazy On You" and "Magic Man," in 1976 for Vancouver, B.C.'s Mushroom Records. Heart moved up to Capitol/EMI Records, showed an ability to evolve with the times, and continued scoring hits with pop gems like "These Dreams" (no. 1), "Never (No. 4), and "All I Want To Do" (No. 2) into the 1990s. Seen on an autographed 1993 promotional shot, Heart also contributed greatly to the Seattle scene, and their state-of-the-art recording facility, Bad Animals studios (2212 Fourth Avenue), would eventually produce hits for the entire grunge generation, including Pearl Jam, Alice in Chains, Soundgarden, and Nirvana. (Above, photography by Karen Moskowitz.)

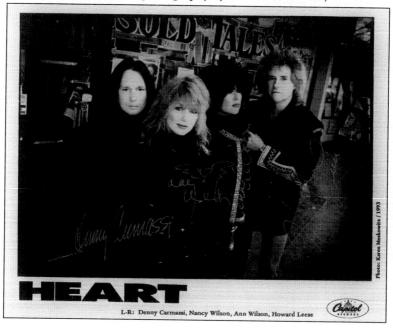

Photo: Karen Moskowitz / 1993

HEART

L-R: Denny Carmassi, Nancy Wilson, Ann Wilson, Howard Leese

Nine

PUNKS, HEADBANGERS, AND HIP-HOPPERS

By the late 1970s, two distinct subsets of vibrant underground rock 'n' roll were simmering in the Pacific Northwest: heavy metal and punk. Both were self-contained scenes that had arisen to a certain degree in cultural opposition to each other. The metal headbanger scene was anchored at suburban roller-skating rinks, while the early punks scuffled by in city community halls and old gay dives. The metal kids received periodic coverage in the mainstream metropolitan papers, while the punks celebrated themselves in new music rags like *Chatterbox*, *Stellazine*, the *Rocket*, *Desperate Times*, and *Backlash*.

But while Seattle's best post-punk bands largely failed at attracting the eyes or ears of the outside music industry, many local metal bands did win big-time recording contracts, including TKO (Infinity), Widow (CBS), Fifth Angel (Epic), Forced Entry (Combat), Heir Apparent (Capitol), Metal Church (Elektra), Sanctuary (Atlantic), and of course the mega-successful Bellevue band that earned a global reputation as the "thinking man's metal band," Queensrÿche (EMI).

But few, if any, of those bands—punk or metal—were making music whose Northwest roots were particularly identifiable or that created the sort of aura about them that might cause fans (or the business) to focus greater scrutiny on the geographical place of their origins. But one musician would emerge from Seattle and make such a huge splash that everyone would wonder, "Where in the world did that come from?" That fellow was no punk or headbanger. He was Sir Mix-a-Lot, the region's first rap star.

Sir Mix-a-Lot's genius was to resist any temptation to copy hip-hop styles from the Bronx or South Central Los Angeles and instead create a sound that reflected a strictly local esthetic. Mix's 1986 hit even played upon the expected prejudices he knew outsiders would have for a rapper hailing from the Northwest. "Rodeo Rap" poked fun with a rhyme based on a hokey sort of "do-si-do" cowboy barn-dance vibe—an idea so unusual and effective that it became a global curio hit, the first of many for Mix. And once again, the world learned that the Pacific Northwest was rich with surprises.

foto=griswold

SCREAMERS FANS UNITE!!

The OFFICIAL SCREAMERS FAN CLUB has been in existence now for one year-- HERE'S YOUR CHANCE TO BECOME AN OFFICIAL SCREAMERS FAN! Membership will include receiving the OFFICIAL NEWSLETTER full of exclusive photos and inside news, all information on when and where the SCREAMERS perform, OFFICIAL SCREAMERS buttons and other paraphenalia, AND anything else we can come up with to make your SCREAM-DREAM come true!

For full membership privileges fill out the following application and send two dollars ($2.00) in cash to the OFFICIAL SCREAMERS FAN CLUB
1845 North Wilton Place
Hollywood, California
90028 USA

A BETTER WORLD BEGINS WITH YOU!

On May 1, 1976, Seattle saw its first punk rock show that featured three local bands (the Tupperwares, Meyce, and Telepaths). The Tupperwares evolved into one of the world's first synth-wave bands, the Screamers. The Telepaths became the Blackouts, and by 1978, the Meyce's guitarist/singer Jim Basnight resurfaced with an early power pop band the Moberlys, who issued the first local album of the DIY (do-it-yourself) era—a disc named by *Trouser Press* magazine as one of their "Underground Top-10." (Left, photography by Griswold.)

THE MOBERLYS

ROCK IN CONCERT !!!SEATTLE!!. mentors SPECIAL GUESTS ROLAND ROCK THE LEWD THE FEELINGS CHINAS COMIDAS * BASNIGHT * VIOLENT WORLD $2.00·ONE NIGHT ONLY · I.O.O.F.HALL 915 E.PINE 5 MAY 5

This classic 1978 poster promoted a fabled show at the Odd Fellows Hall (915 East Pine Street) featuring a few of Seattle's first generation punk bands, including the infamous executioner-hooded Mentors. The Lewd self-issued their *Kill Yourself* record in 1979. Their singer, Satz Beret, had come from Seattle's post-hippie/glam troupe Ze Whiz Kids, and guitarist Blobbo (Kurdt Vanderhoof) went on to form the 1980's band Metal Church. (Below, photography by Saulius Pempe.)

the LEWD "KILL YOURSELF"

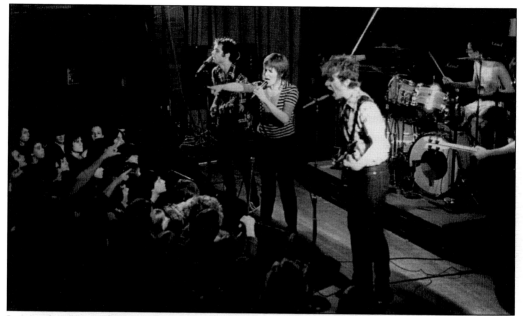

In March 1979, the Enemy opened Seattle's first all-ages punk rock room, the Bird. The authorities weren't pleased. First the fire department dogged the place, and then a violent police raid marred the closing night party in May. A tape recording of that incident was used as an intro to the Enemy's subsequent 45, "Trendy Violence." (Courtesy Peter Barnes.)

The Debbies debuted in 1979 opening at the Showbox Theater for British headliners Fingerprintz and were soon on the cover of the *Seattle Weekly* and identified as " 'the hot new band' with the Seattle New Wave hip." They shared various bills with the Blackouts, Skinny Ties, Pink Section, Beakers, Macs Band, and Connections at venues including the Showbox Theater, Gorilla Room (610 Second Avenue), Wrex (2018 First Avenue), and Portland's Urban Noize (SE Sixth Avenue and Stark Street) into 1981. (Photography by Larry Simpson.)

The Telepaths released one of Seattle's first punk-era singles, "Make No Mistake," in July 1978, morphed into the Blackouts in 1979, and are seen here live in October 1980 at the Showbox Theater. In time, members would resurface on the East Coast with the ultra-heavy industrial rock band, Ministry. (Courtesy photographer Cam Garrett.)

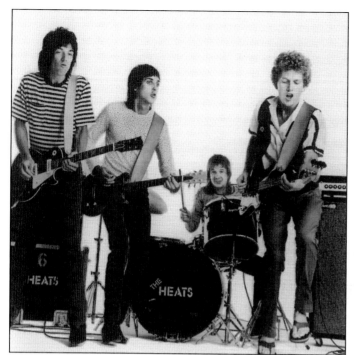

The Heats emerged in 1979, and the bright vocal harmonies of (former Moberlys) guitarists Steve Pearson and Don Short, coupled with the catchiness of their snotty power pop radio hit "I Don't Like Your Face," made them Seattle's hottest new group. The band was also the first to benefit from the accumulated experiences of Heart. Heart's manager Ken Kinnear of Albatross Management and Jon Kertzer began guiding the Heats, and their 1980 LP *Have an Idea* was even produced by Heart guitarist Howard Leese. (Photography by Chuck Kuhn.)

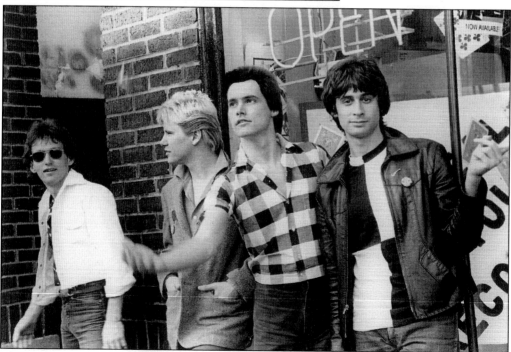

The Cowboys challenged the Heats' incredible popularity with a tougher sound, another former Moberlys' guitar ace Jeff Cerar (middle/right), and boisterously rowdy front man Ian Fischer (middle/left). The two rival bands each helped expand the scene by convincing club owners that the new wave of local rock bands could in fact draw crowds with a mixture of peppy original tunes and popular hits of the day.

The Visible Targets

In 1980, a Yakima band, Wreckless, moved to Seattle, renamed themselves the Visible Targets, and the sisters-led group became a very successful participant in the area's burgeoning new wave scene. Cool vocals, quirky yet solid drumming, and great originals like "Just For Money" (Sub Pop) and "Twilite Zone" (Park Avenue Records) won them a spot on a tour opening for the hit Scottish band Simple Minds. (Photography by Rex Rystedt.)

Scott Soules presents

THE ALLIES

The Allies were the next Seattle band whose power pop sound earned them an enthusiastic fan base, the devotion of the local mainstream media, and ultimately an MTV *Basement Tapes* win for the video to their seductive 1982 song "Emma Peel."

The Chains of Hell Orchestra were among the very first Northwest bands that the new Olympia-based label Sub Pop issued recordings by. They are seen in 1983 backstage at Seattle's punk hall the Metropolis (207 Second Avenue S), just prior to the release of their psychedelic biker rock concept EP *One Bad Trip*. (Courtesy photographer Cam Garrett.)

By 1982, a full-on heavy metal scene had taken root in the Bellevue area where headbanger dances at the Lake Hills roller skating arena featured legions of poodle-haired, spandex-clad bands, such as Culprit, Myth (with future Queensrÿche vocalist Geoff Tate), and the Wild Dogs.

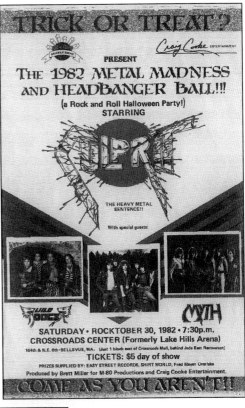

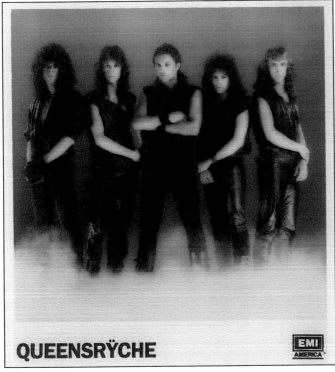

QUEENSRŸCHE

Originally formed as the Mob in 1981 by members of various other heavy metal bands (including Cross+Fire and Babylon), this Bellevue band cut a demo tape that received such glowing reviews that the group, now renamed Queensrÿche, self-released it on disc and got Geoff Tate to quit Myth to join them permanently. In 1983, they were signed by EMI Records and have issued nine acclaimed albums, including 1988's *Operation: Mindcrime*, which was hailed by critics as a masterpiece, and 1990's *Empire*, which hit the No. 7 slot on *Billboard* and yielded the No. 7 single "Silent Lucidity."

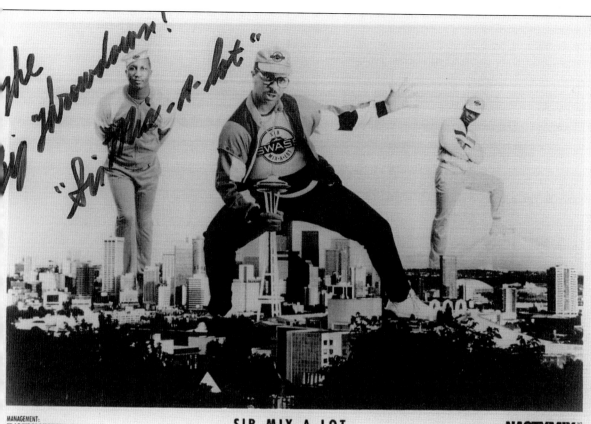

MANAGEMENT:
ED LOCKE PROMOTIONS, INC.
87 Wall Street, 2nd Floor
Seattle, Washington 98121
206-441-8802

SIR MIX-A-LOT

NASTYMIX RECORDS

Seattle's first hip-hop star Sir Mix-a-Lot helped launch Nastymix Records in 1985 and a number of his tunes—like 1988's "Posse On Broadway" and 1989's "Beepers" (a No. 1 national rap hit)—helped the rapper sell millions of units. Mix eventually formed a new label called Rhyme Cartel and then moved up to American Recordings. In 1992, his "Baby Got Back (I Like Big Butts)" became a Grammy Award–winning, No. 1 smash. Always open to fresh ideas, Mix has collaborated with area rock bands including Mudhoney, Metal Church, and the Presidents (in a side project band called Subset), and he also contributed to the scene by producing a compilation CD of various rappers called *Seattle . . . The Dark Side.*

Ten

THE
GRUNGE GENERATION

Just as the 1980s were winding down, a remarkable thing occurred: a few dozen players who'd risen through the ranks of either the local punk or metal scenes apparently realized that they actually had an affinity for various aspects of both scenes' esthetics. In short, the instrumental prowess required for great metal music was worthy of admiration, and the socially aware lyrical content of the best of punk rock was intellectually appealing. So why not combine the two? And with that realization, Seattle rock 'n' roll was about to take a daring leap perhaps best summed up by this math equation: Punk + Metal = Grunge.

A bunch of long-haired, flannel-clad players begin to coalesce into new bands and forge a sound that would soon be globally admired. From the earliest gigs at dingy rooms like Seattle's Central Saloon, Ditto Tavern, Vogue, OK Hotel, Squid Row, and RKCNDY, the grunge esthetic—both the music itself and the graphics it was marketed with—was solidifying into an iconic form.

The years spanning 1991 through about 2005 can now be viewed as an historic high-water mark for the Pacific Northwest's long-struggling music scene. Not only did local musicians achieve unprecedented levels of artistic and commercial success, but the local music industry (especially Seattle's KNDD radio and influential labels like K Records, Kill Rock Stars, C/Z, and Sub Pop Records) had finally nurtured an exciting movement that took the world by storm, conquered all of musicdom, and has subsequently been acknowledged by historians as the dominant musical trend of the late 20th century.

Naturally such extreme success left behind a multipart legacy. Certainly grunge brought serious new monetary wealth to the region—enough to finance the building of many new state-of-the-art recordings studios, rehearsal studios, nightclubs, and record labels. But the grunge boom also created a reservoir of experiential wealth—the audio engineers, record label staffs, business managers, radio DJs, critics, photographers, poster designers, filmmakers, club owners, and retailers who perfected their craft and still remain here, greatly benefiting local music fans and the next generation or two of up-and-coming musicians.

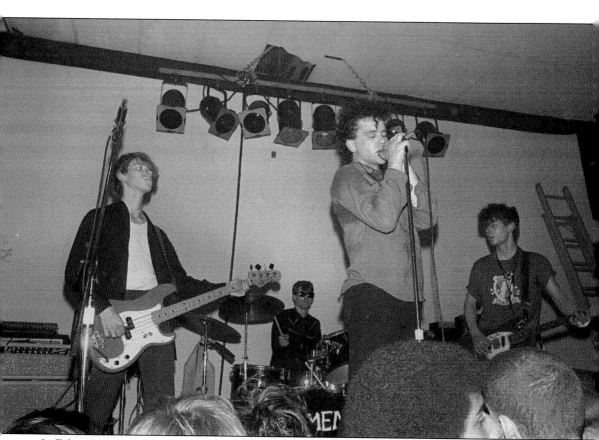

In February 1986, a new Seattle label, C/Z Records, issued a remarkable compilation LP, *Deep Six*, which featured songs by six deep local bands: Soundgarden, Green River, Melvins, Malfunkshun, Skin Yard, and the U-Men, who'd first forged their proto-grunge music back in 1980 and are seen here in 1985 at Seattle's Gorilla Gardens (410 Fifth Avenue S). (Courtesy photographer Cam Garrett.)

Soundgarden formed in Seattle back in 1984 and performed for C/Z's *Deep Six* release party (seen here) at the UCT Hall (Fifth Avenue and Aloha Street) on March 21, 1986. In 1987, Sub Pop issued their *Screaming Life* disc; in 1988, SST issued their Grammy-nominated *Ultramega OK* LP; and in 1989, they became the first Seattle band of their generation to be signed to a major label when A&M Records issued their *Louder Than Love* LP. MTV hits like "Outshined" and "Rusty Cage" followed, as did 1994's *Superunknown* album, which debuted on *Billboard* at No. 1 and yielded four international hits, including the Grammy Award–winners "Spoonman" and "Black Hole Sun." One album and a handful of singles later, Soundgarden disbanded in 1997. (Courtesy photographer Cam Garrett.)

Malfunkshun, with charismatic singer/bassist Andrew Wood, is seen performing at the *Deep Six* event at the UCT Hall on March 22, 1986. Wood went on to help found Mother Love Bone, a promising band that first shocked Seattle by signing to the big-time label Polygram Records, and then shocked the town again when Wood died of a drug overdose just days before their album was released in March 1990. (Courtesy photographer Cam Garrett.)

First formed in 1984, Green River simply stunned their Seattle audiences at shows like this one on March 14, 1986, at the Rainbow Tavern (722 Northeast Forty-fifth Street). But in time, spats about whether or not to chase down a major recording deal split the band and various members went on to form such groups as Mudhoney, Mother Love Bone, and Pearl Jam. (Courtesy photographer Cam Garrett.)

Months after forming in 1985, Ellensburg's Screaming Trees cut *Clairvoyance*, a debut LP showcasing their trademarked brand of psychedelic/punk rock. The band was then able to jump to SST Records, recording the classic album *Even If and Especially When* and in 1989 recorded for Sub Pop. Then, in 1990, the band moved to Epic Records, and at the peak of grungemania in 1992, they scored a sizable MTV and alternative radio hit with "Nearly Lost You." Then, after performing at the grand opening for Seattle's music museum, the Experience Music Project, on June 25, 2000, the Screaming Trees announced their breakup.

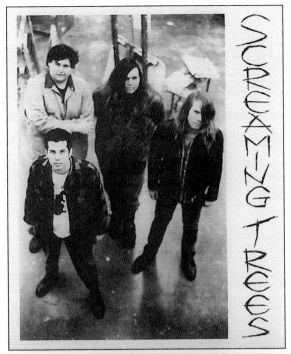

In August 1989, Bellingham's Mono Men self-issued their debut 45 "Burning Bush," an instant Northwest classic that helped kick start a decade-long international garage rock revival. Numerous additional records, like *Stop Dragging Me* and *Wrecker* (each an aural homage to Sonics-style, old-school garage rock), were issued on Estrus Records—the fun label run by guitarist Dave Crider—before the group disbanded in 1998. (Courtesy Dave Crider.)

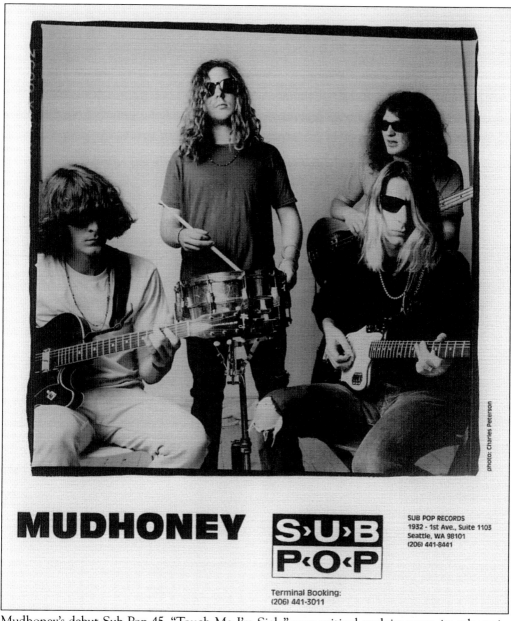

MUDHONEY

S·U·B P·O·P

SUB POP RECORDS
1932 · 1st Ave., Suite 1103
Seattle, WA 98101
(206) 441-8441

Terminal Booking:
(206) 441-3011

Mudhoney's debut Sub Pop 45, "Touch Me I'm Sick," won critical acclaim upon its release in August 1988, and they joined other grunge bands, Nirvana and Tad, on a European tour in 1989 where they were collectively heralded as rock's potential new saviors. Great follow-up discs like *Superfuzz Bigmuff* eventually got the band signed to a major label, Warner Brothers, where they cut three albums before coming home to Sub Pop. (Photography by Charles Peterson.)

ALICE IN CHAINS

SILVER-CURTIS MANAGEM
219 1st Avenue South, Suite 2
Seattle, WA. 98104. (206) 623-9
FAX: (206) 622-1344

In 1987, Alice in Chains emerged from the local metal scene—singer Layne Staley (right) and guitarist Jerry Cantrell (left) had previously played speed metal music in the band Diamond Lie—and their first of several hit singles with Epic Records, "We Die Young," was issued in July 1990. Later that year, "Man in the Box" became a big MTV hit; in 1992, their hit-laden *Dirt* album went platinum. In 1993, they joined the Lollapalooza Tour, and in 1994, their *Jar of Flies* debuted at No. 1 on the charts. In 1995, their *Alice in Chains* debuted at No. 1. Sadly though, the band then lost momentum, and Staley died tragically of a drug overdose in 2002.

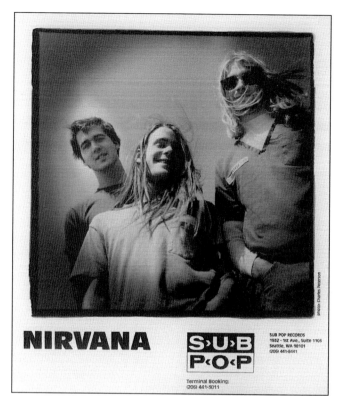

The first Sub Pop promotional photograph for an early lineup of Aberdeen's soon-to-be-famous band, Nirvana, shows guitarist Kurt Cobain (right), bassist Krist Novoselic (left), and short-term drummer Chad Channing. (Photography by Charles Peterson.)

Nirvana's rare, limited, and numbered edition (this one is No. 60) debut 45 "Love Buzz"/"Big Cheese" was issued in July 1988 by Seattle's Sub Pop label as part of their clever pay-before-you-hear it Singles Club. Sub Pop's tongue-in-cheek corporate goal of "World Domination" initially provoked chuckles, but awesome product like this single and the 1989 album *Bleach* would soon make that seemingly delusional boast a reality. (Photography by Alice Wheeler.)

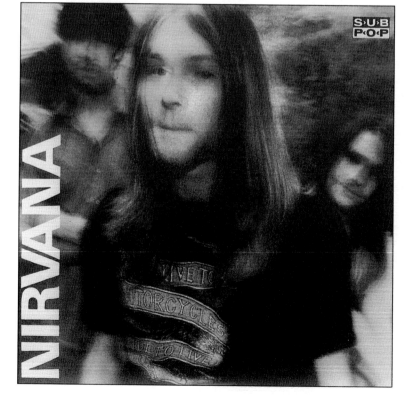

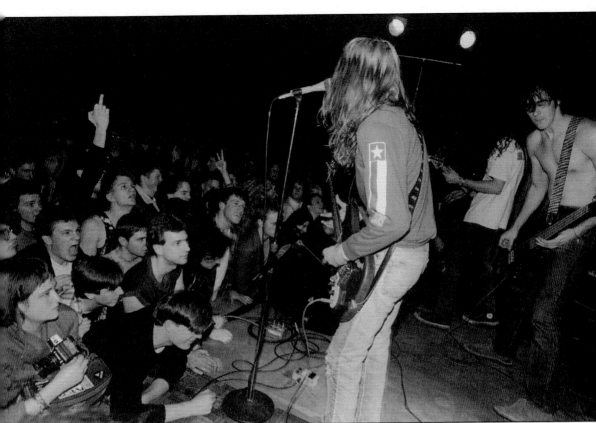

Nirvana is pictured rocking a largely appreciative crowd at the University of Washington HUB ballroom on February 25, 1989—a full two-and-a-half years before the band's "Smells Like Teen Spirit" Geffen Record single (and the universally esteemed *Billboard* No. 1 album *Nevermind*) rocketed the grunge movement into a global phenomenon. Follow-up hits like "Come As You Are" and "Heart Shaped Box" also received massive radio and MTV play, and the 1993 album *In Utero* debuted at No. 1 on *Billboard*. Despite Cobain's shocking death in April 1994, the band's impact was so strong that all these years later *Nevermind* is routinely included in any listing of best albums in rock history, just as Nirvana gets ranked in the top tier of all-time best bands. (Courtesy photographer Charles Peterson.)

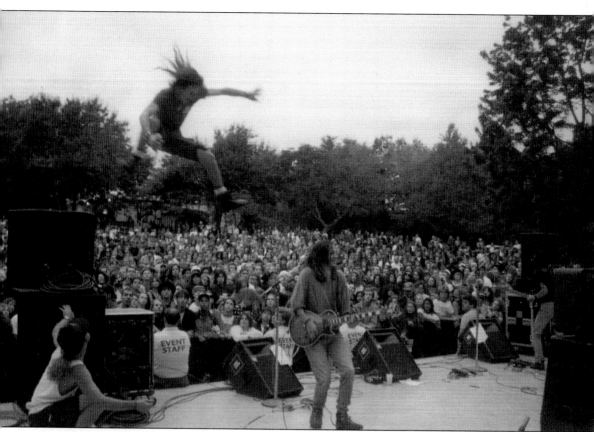

Pearl Jam rose from the ashes of Mother Love Bone when guitarist Stone Gossard (center) and bassist Jeff Ament recruited guitarist Mike McCready from the local metal band Shadow, a drummer, and a singer named Eddie Vedder. The band made their live debut on October 22, 1990, at Seattle's Off Ramp Tavern (109 Eastlake Avenue E) and quickly formed a following. Then Pearl Jam played this thrilling show at the Seattle Center's Mural Amphitheater at just about the point in mid-1991 that the young band's debut Epic Records single "Alive" took off. When the album *Ten*—with hits like "Evenflow," "Jeremy," and "Black"—was released in August, the band's reputation for masterful musicianship, intelligent lyrics, and passionate vocals was nailed down tight. (Courtesy photographer Lance Mercer.)

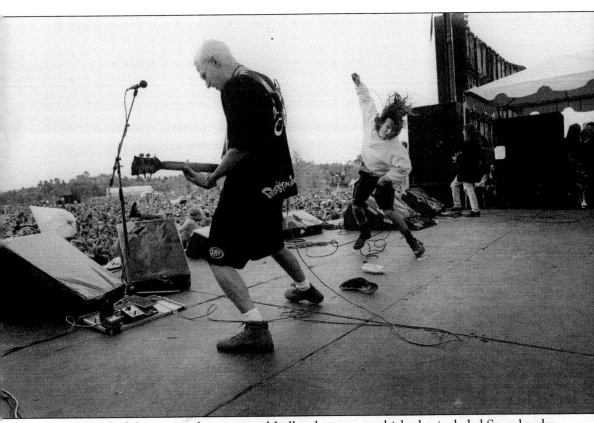

At the end of the summer-long national Lollapalooza tour, which also included Soundgarden, Pearl Jam performed before 29,000 ecstatic fans at a free outdoor Rock the Vote voter registration drive concert at Seattle's Magnuson Park on September 20, 1992. Still touring internationally with eight albums, a good dozen hit singles, a Grammy Award, and many MTV and American Music Awards now under their belt, Pearl Jam, who has also received recognition as the most popular American rock band of the 1990s, exist today (along with Mudhoney) as the last-standing major band of the entire grunge generation. (Courtesy photographer Charles Peterson.)

DISCOVER THOUSANDS OF LOCAL HISTORY BOOKS
FEATURING MILLIONS OF VINTAGE IMAGES

Arcadia Publishing, the leading local history publisher in the United States, is committed to making history accessible and meaningful through publishing books that celebrate and preserve the heritage of America's people and places.

Find more books like this at
www.arcadiapublishing.com

Search for your hometown history, your old stomping grounds, and even your favorite sports team.

Consistent with our mission to preserve history on a local level, this book was printed in South Carolina on American-made paper and manufactured entirely in the United States. Products carrying the accredited Forest Stewardship Council (FSC) label are printed on 100 percent FSC-certified paper.

MADE IN THE USA